KU-875-216

759.4 (034)

Painters of Light

Painters of Light

THE WORLD OF IMPRESSIONISM

Keith Roberts

Phaidon · Oxford

Phaidon Press Limited, Littlegate House,
St Ebbe's Street, Oxford

First published 1978
Published in the U.S.A. by E. P. Dutton
© 1978 Phaidon Press Limited
Text © 1978 by Keith Roberts
All rights reserved

ISBN 0 7148 1850 X
Library of Congress Catalog Card Number: 78-55001

Printed in Great Britain by Waterlow (Dunstable) Limited

List of Plates

Bibliographical Note

The literature on Impressionism is vast; and much of it is highly specialized. For the general reader, seeking orientation in a complex field, the best general study is still John Rewald's *History of Impressionism*, first published in 1946 and now in its fourth, revised edition (1973), complete with a first-class, updated bibliography of its own. The book, distributed in the United Kingdom by Secker and Warburg, is published by the Museum of Modern Art in New York. John Rewald's sequel, *Post-Impressionism: From Van Gogh to Gauguin* (second edition, 1962), continues the story and is just as invaluable.

Footnotes would be out of place in as brief a survey as this; but the author would none the less like to express his debt to the work of —among many others—Wendy Baron, Jean Sutherland Boggs, Douglas Cooper, François Daulte, George Heard Hamilton, John House, Lulli Huda, Richard Ormond, Ronald Pickvance and Theodore Reff.

Introduction

Painting has a long history. A rich past tends to produce symbolic heroes with unattainable and unquestionable levels of accomplishment; and for three centuries European art developed under the lengthening shadows of Raphael, Michelangelo, Titian and their great contemporaries. A consensus of opinion grew up between artist and patron, collector and critic, as to what art was about and, while obviously bad for those unable or unwilling to share its assumptions, this at least helped to maintain the momentum of artistic production.

By the middle of the nineteenth century, however, the traditional possibilities of Renaissance and Baroque art were more or less exhausted. The classicist position was further eroded by the withdrawal of large-scale ecclesiastical patronage, the decline in classical education and even by changes in the social structure. The temper of the times, with its emphasis on rational explanation and scientific inquiry, also worked against the philosophical concept of ideal beauty that underpins so much Renaissance painting and sculpture. The truly significant books of the age were not the equivalent of Gibbon's *Decline and Fall of the Roman Empire* but Darwin's *Origin of Species* (1859) and Marx's works on capital and labour.

Traditional forms of art did not of course disappear. Official exhibitions, such as the annual Royal Academy shows and Paris Salons, were filled year after year with high-minded works that duly won medals. And they sold, partly because the many new middle-class patrons tended to be socially nervous and therefore conformist in their taste. Wiser minds recognized the symptoms of general exhaustion and were not usually happy with the implications of what they saw. The great critic, John Ruskin (1819-1900), longed for a renewal of religious painting, and took the severest view of frivolous work, but had to admit that the most original contribution to the art of the nineteenth century actually lay in landscape. With the advantage of hindsight, it is relatively easy to see not only that this is correct but also why it is true. The full potential of landscape as a theme, which in the old hierarchy was ranked inferior to uplifting illustrations of Biblical and historical subjects, had for too long been confined within idealizing formulae going back to the seventeenth century. It was a subject still brimming with unrealized possibilities; and it is no accident that the Impressionists made their most original and important contributions to art as painters of landscape (Plates 1, 14, 30 and 36).

The Romantic Movement, with its worship of nature as a source of spiritual and moral refreshment, first began to loosen many of these aesthetic inhibitions and formulae. Constable (1776-1837), Turner (1775-1851) and Corot (1796-1875) were the three great

7

masters of landscape in the first half of the nineteenth century; but each, in his own way, still had to face up to the problem of 'finish': how to reconcile the spontaneity of the original conception or oil sketch with the degree of careful execution and detail demanded by the critics and the organizers of the crucial, reputation-making public art exhibitions of the day.

Turner, it is true, exhibited some very free paintings at the Royal Academy in the 1830s and 1840s, but these were badly received, often dismissed as a joke and only tolerated as the aberrations of an artist with an enormous reputation solidly based on landscapes in the tradition of Claude, Cuyp, Ruisdael and Van de Velde. Corot, a timid man at the best of times, never attempted to fight the system. His Claudian exercises regularly went to the Salon: but none of his entrancing oil sketches, on which his modern reputation legitimately rests, was exhibited during his lifetime.

If the history of nineteenth-century art is the story of a linked series of revolutionary movements and styles, from Romanticism to Pointillism and Symbolism, it is also a tale of continued public nervousness and suspicion in the face of the new developments. A little ground might be won, and some of the new achievements absorbed into the general aesthetic bloodstream, but the public was as conservative (and as hysterical) about art as about moral questions. The two subjects are, indeed, intimately connected. Impressionist art was frequently attacked as 'filthy' and 'low'; and any nude was automatically branded as a prostitute (see Plates 11 and 15).

When the Impressionists exhibited their loosely painted and boldy conceived landscapes (such as Plates 30 or 36), critics and public were quick to attack the new art. The word 'Impressionism' was originally coined by a journalist called Louis Leroy. He used it in the spring of 1874 in a review of the first Impressionist group exhibition published in the satirical magazine, Le Charivari, and it was intended to be dismissive. Paintings such as Monet's Impression, Sunrise (Paris, Musée Marmottan) were merely an 'impression' of nature, nothing more.

To the late twentieth-century public this is bound to seem puzzling because the pictures in question can be so enchanting. But two factors need bearing in mind. The nineteenth century tended to be both earnest and shrewd; and much conventional art was so highly finished that the buyer could feel confident that he was not only buying a 'masterpiece' but also getting value for money. Impressionist painting shocked partly because it seemed slapdash: it was, apart from anything else, a shoddy piece of merchandise. It also offended a public that liked having its emotions aroused. Paul Huet (1803-69), for example, was a successful and respectable landscape painter in the Romantic vein. His Flooding at Saint-Cloud (Plate 55), which was acquired for the collection of Emperor Napoleon III, is very large in scale and dark in tone. The tiny house visible between the rows of trees increases the feeling of distance and, by gloomy contrast, emphasizes the brooding menace of Nature. Huet dramatizes the subject and gives it something of the resonance of the Biblical Flood; the picture revels in the same kind of luxurious despair as the grand operas of the day, with their scenes of madness and treachery, revenge and death. Sisley's painting of a comparable theme (Plate 54) looks in comparison very tame and rather flat; to the public of 1876 it would have seemed unfinished emotionally as well as technically.

In any consideration of Impressionism it is always wise to take account of the opposition. The Impressionists were reacting against the conservative art of their time, but the forms

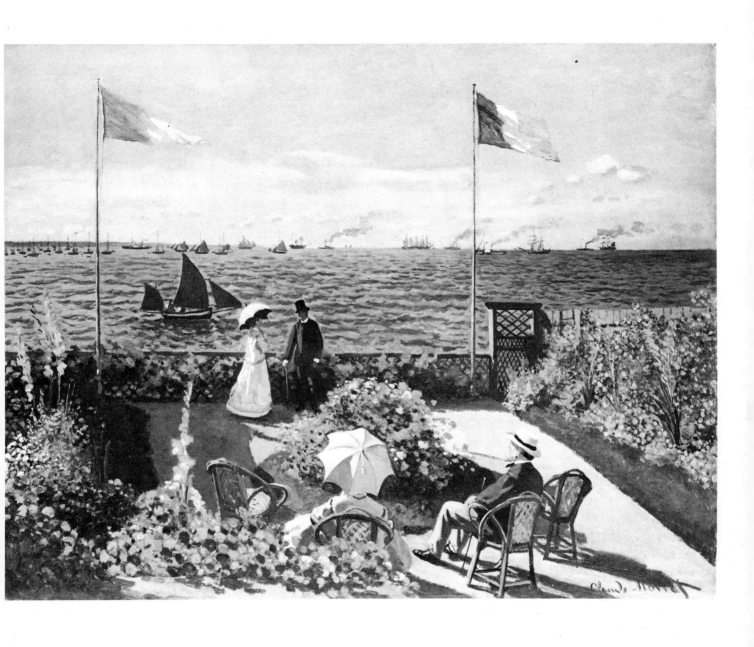

1. Claude Monet (1840–1926): *Terrace at Sainte-Adresse*. Signed; 1867. Canvas, 98 × 130 cm. (38½ × 51 in.) New York, Metropolitan Museum of Art

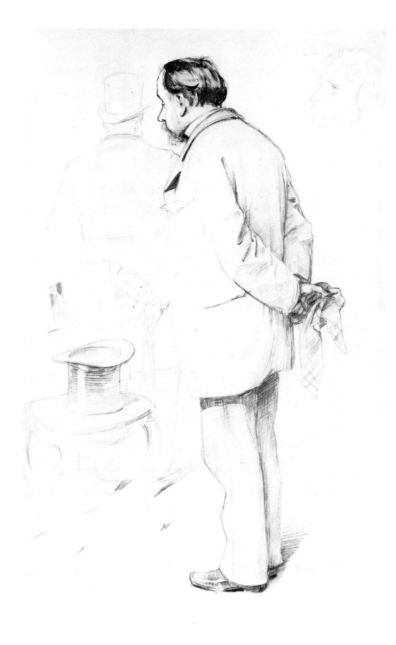

2. Paul Mathey (1844–1929): *Portrait of Degas*. Signed and dated 1882. Pencil, 48.3 × 31.8 cm. (19 × 12½ in.) Formerly London, Lefevre Gallery

their reaction took were often shaped by what they most loathed. The Establishment approved of art with a strong narrative content: so Monet (Plates 13 and 26) and Degas (Plate 47) drained their images of any ostensive literary meaning. Popular taste in the 1860s admired idealized forms, especially when it came to the female nude, and made much of the Old Masters' elevated taste in such matters: so Manet painted a very modern and distinctly unidealized nude in the same pose as Titian's *Venus of Urbino* (Plate 15).

Critics still believed that landscape should be idealized and the elements carefully composed, with a variety of viewpoints, framing trees, and so on: Pissarro (Plate 28), Sisley (Plates 30 and 54) and Monet (Plate 14) therefore produced seemingly casual 'snapshots' of familiar suburban scenery, complete with modern bridges, and devoid of framing elements and other picturesque details. They believed in a type of landscape painted out of doors that would truthfully record how nature actually looked; and against received opinion, which laid down strict rules about colour modulation, especially in shadows, the Impressionists tried to record faithfully how various colours were affected by the play of light and atmosphere.

The accepted rules about pictorial space still reflected the Renaissance conception of the picture as a kind of window looking on to a world with a single, carefully worked out vanishing point, and with all the details evenly disposed in a manner calculated to reassure the spectator. Degas, whose ideas about composition were the most advanced and interesting of any of the Impressionists, designed his pictures so that a figure might be cut in half by the edge (Plate 52), half the space might be empty (Plate 58) and the viewpoint well above or well below the pictorial action (Plate 33). Partly under the influence of Japanese prints (which were greatly admired

by nearly all the leading Impressionists), Degas also came to stress the flatness of his pictures and so make the spectator increasingly aware of the surface of the canvas itself, thus weakening the illusion of the image.

Impressionism was evolved in the 1860s, perfected in the early 1870s, and lost its freshness and momentum in the 1880s, when it was superseded by Post-Impressionism, which is popularly thought to be much the same thing but is actually very different in character and method, and barely touched on in this book. The 1860s were the formative years when the major artists first came together in the teaching studios in Paris, especially the Académie Suisse and the Atelier Gleyre. They were all born between 1830 and 1841, and when hostility broke out against them on a massive scale in 1874 were still too young to be able (like Turner) to count on years of public enthusiasm for earlier and more conventional work.

Camille Pissarro (1830-1903) was the eldest and came to be regarded as something of a father figure; he had been a pupil of Corot, whose landscapes painted in the open air, going back to the 1820s, were not without influence in the evolution of Impressionism. Edouard Manet (1832-83), who died relatively young, was in many ways the most conservative of the group: he longed for official recognition and honours and never wholly shook off the influence of the Old Masters, especially Spanish artists such as Velasquez and Goya. Edgar Degas's career was brought to a premature close by failing sight; he was born in 1834 but produced little of consequence, apart from wax sculpture (see Plate 75), after about 1900, though he lived until 1917. He had studied with a pupil of Ingres, was a brilliant draughtsman, and was reluctant to carry the disintegration of form in sunlight as far as Monet or Renoir. He was artistically the best educated of all the

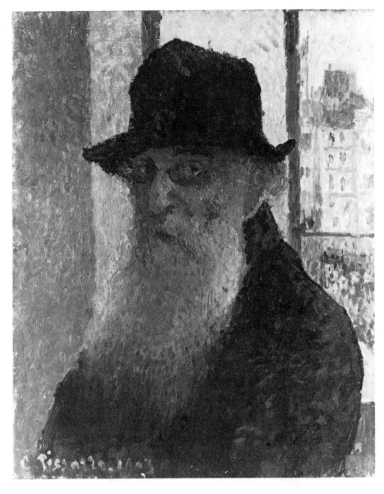

3. Camille Pissarro (1830–1903): *Self-portrait*. Signed and dated 1903. Canvas, 41 × 33 cm. (16⅛ × 13⅛ in.) London, Tate Gallery

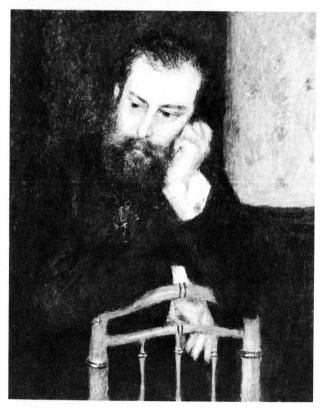

Impressionists, one of the great copyists in the history of European art, and a profound admirer of the classical tradition going back to the Renaissance. His highly original art rests on the surest of foundations; and he knew it. Degas summed up his position in an epigram: 'Ah, Giotto, don't prevent me from seeing Paris; and, Paris, don't prevent me from seeing Giotto.'

Alfred Sisley (1839-99) was the least imaginative member of the group. He painted virtually nothing *but* small landscapes, which decline in quality after about 1878. Paul Cézanne (1839-1906) is always placed among the Impressionists—and, indeed, exhibited with them—but is best seen as a Post-Impressionist. He did not come to maturity as an artist until the very end of the 1870s, when almost all the best Impressionist pictures had been painted, and his preoccupation with a particular kind of pictorial structure also links him with the later movement (see Plate 69). Claude Monet (1840-1926) was arguably the most brilliant painter of landscape in the group and certainly the artist who carried the depiction of optical sensations the furthest. He was the last of the major figures to die and was still at work on his profoundly original water-lily pictures in the 1920s. Pierre-Auguste Renoir (1841-1919) painted all kinds of pictures—landscapes, mythological scenes, still-life, portraits—but is rightly remembered for his mastery of the female nude (Plate 41), which was not otherwise a regular Impressionist theme.

4. Camille Pissarro (1830–1903): *Portrait of Paul Cézanne.* 1874. Canvas, 92 × 59 cm. (36¼ × 23¼ in.) Formerly Basle, Robert von Hirsch

5. Pierre-Auguste Renoir (1841–1919): *Portrait of Alfred Sisley.* Signed; about 1874. Canvas, 65.1 × 54 cm. (25⅝ × 21¼ in.) Chicago, Art Institute

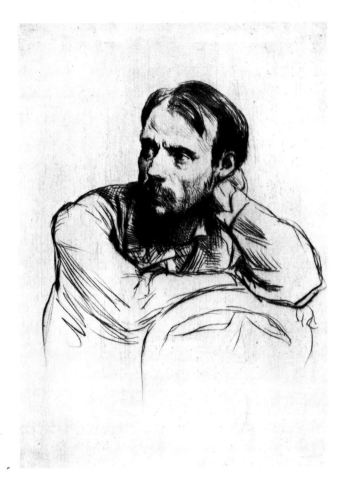

The heroic years of Impressionism, from the late 1860s to about 1876, will always be associated with the small landscapes painted out of doors on the banks of the Seine (Plate 14). It was here, at Argenteuil, that Monet and Renoir perfected the technique of breaking up the forms to be described into touches of pure colour that only fuse back into what they represent when the canvas is seen from a certain distance. Sisley's exquisite *Bridge at Villeneuve-la-Garenne* (Plates 29 and 30) also shows this method to perfection.

Why, admirers may well ask, did the Impressionist movement last for such a short time? For there is no doubt that the original impetus was only maintained for ten to eleven years, and not all of them vintage. The main reason, which touches on the general evolution of art, is that the Impressionists simply exhausted the possibilities of the programme they had set themselves. And the fact that they produced so much quickened the demise of the movement in its first and most classic form. But Impressionism was not just about a particular vision, a specific type of landscape or figure subject and nothing more. It was also about a way of seeing, a new approach to the problems of painting. It was a great liberating force that enabled the original group to go their different ways in the 1880s, just as it offered much younger artists, such as Sargent (Plates 60 and 62) and Sickert (Plates 72 and 74), challenging points of departure for their own careers. And Impressionism was to become one of the cornerstones of modern painting.

6. Marcellin Desboutin (1823–1902): *Portrait of Pierre-Auguste Renoir*. 1877. Etching, 15.9 × 11.1 cm. (6¼ × 4⅜ in.) New York Public Library

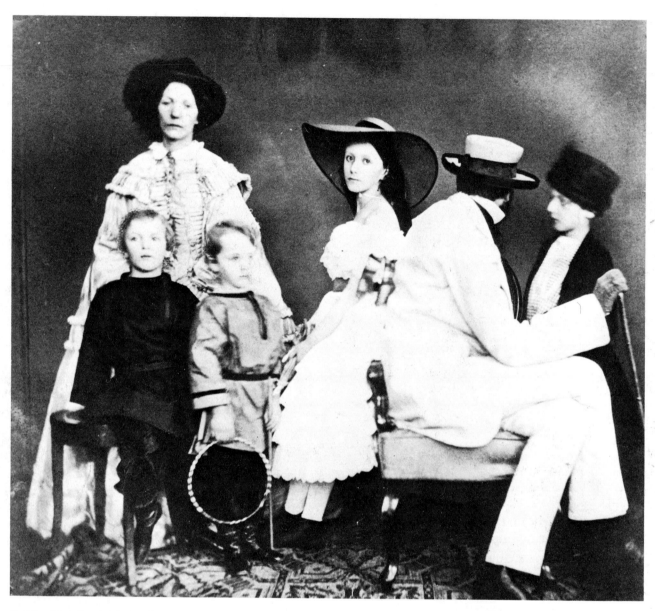

7. The Russian Ambassador to Berlin, Baron von Budberg, and his Family. About 1860. Photograph. Berlin (DDR), Märkisches Museum

The largest of all Degas's portraits, *The Bellelli Family* shows the painter's uncle and his family in their temporary home in Florence. Many preparatory studies survive and demonstrate just how many elements can go into the creation of a work of art. Degas was a great admirer of the Old Masters and *The Bellelli Family* reveals the influence of Van Dyck, Clouet, Holbein and—among older contemporaries—Ingres. But Degas, just then beginning to explore a type of composition that would preserve the spontaneous and informal tone of ordinary life, must also have looked at the newest of art forms, photography. Although he can hardly have known the photograph of Baron von

14

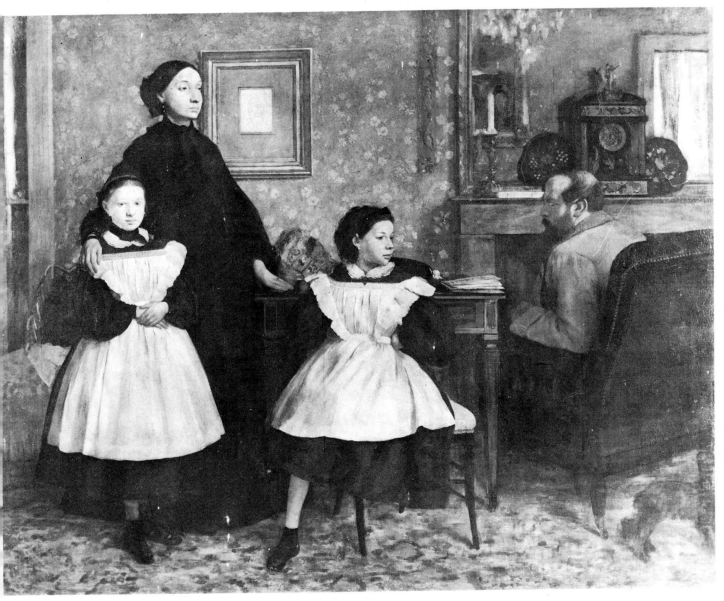

8. Edgar Degas (1834–1917): *The Bellelli Family*. 1858–60. Canvas, 200 × 251 cm. (78¾ × 99½ in.) Paris, Louvre
(Jeu de Paume)

Budberg and his family, he probably saw very similar images, in which an 'accident' (the baron has his back to the camera) adds to the liveliness of the effect. Although head of the family, Baron Bellelli is turned away from the spectator and placed at the side of the composition.

15

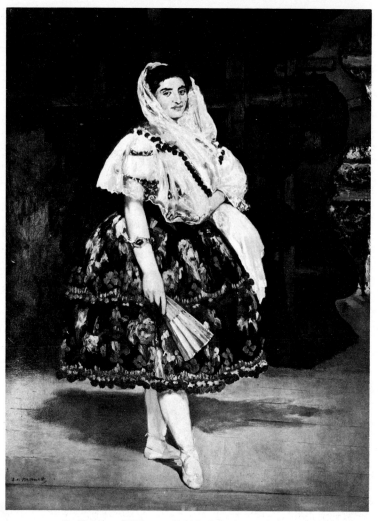

9. Edouard Manet (1832–83): *Lola de Valence*. Signed; 1862. Canvas, 123.5 × 92.1 cm. (48⅜ × 36¼ in.) Paris, Louvre (Jeu de Paume)

A work that shows Manet's sympathy with Spanish painting particularly well. The sitter was a member of a Spanish dance troupe that had a great success in Paris in the autumn of 1862 and inspired several paintings by Manet. If the mood and stance of the figure are Goyaesque, the vignette of the crowded auditorium on the right is characteristically Impressionist, inspired in this case by one of Daumier's lithographs.

Bazille came from Montpellier but soon migrated to Paris (1862), studying in the studio of the academic painter, Charles Gleyre, where he met Monet, Sisley and Renoir. His promising career was tragically cut short by the Franco-Prussian War: he was killed in battle on 28 November 1870. Although, for its date (1868), not as advanced as the work of Monet or Renoir, the *View of a Village* shows well the Impressionist style in embryo: the careful observation of light effects, the use of colour in shadow (note the treatment of grass and bushes on the right), the informal composition, the attempt to depict the model *in* the open air rather than in front of a landscape backdrop, and the choice of a subject without dramatic or sentimental overtones. The handling of the paint is still rather heavy and suggests the influence of Courbet's pictures, which Bazille admired. The model was the daughter of a tenant farmer on his parents' estate near Montpellier. The somewhat conservative air of the *View of a Village* probably explains why it was accepted for the Paris Salon of 1869, for which canvases by both Sisley and Monet were refused. Not that Bazille regarded this as an unqualified triumph; to be turned down by the Salon was in some respects more helpful to the cause of the *avant garde*. 'What pleases me', he wrote in the spring of 1869, 'is that there is genuine animosity against us; it is M. Gérôme who has done all the harm; he has treated us as a band of lunatics and declared that he believed it his duty to do everything to prevent our paintings from appearing; all that isn't bad.' Bazille was one of the models for Monet's *Picnic* (Plate 13).

10. Frédéric Bazille (1841–70): *View of a Village* (*Castelnau*). Signed and dated 1868. Canvas, 130 × 89 cm. (51¼ × 35⅛ in.) Montpellier, Musée Fabre

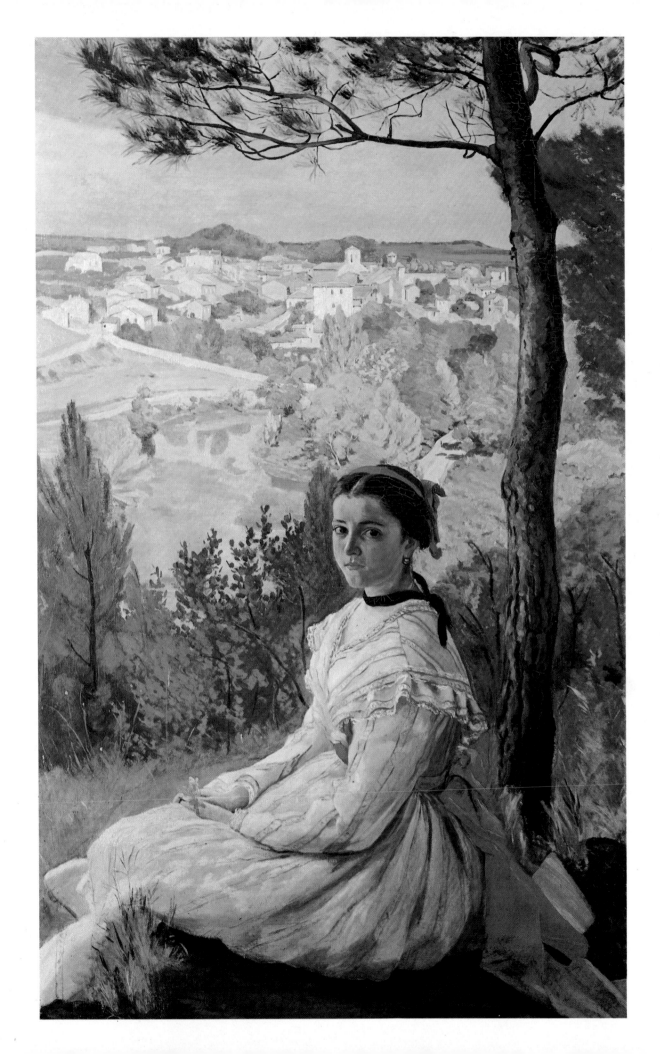

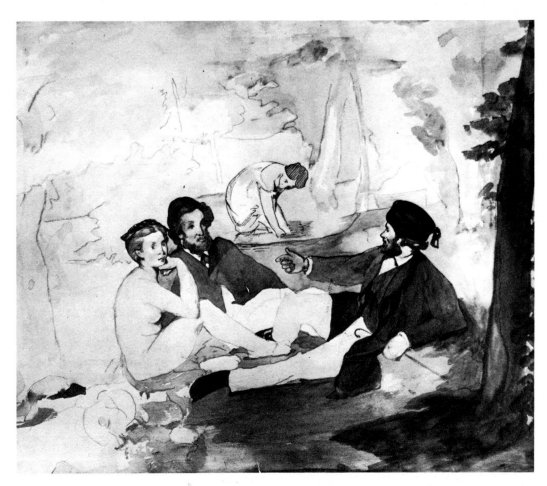

11. Edouard Manet (1832–83): *The Picnic* (*Le Déjeuner sur l'Herbe*). 1862–3. Pencil and watercolour, 34 × 40.5 cm. (13⅜ × 15⅞ in.) Private Collection

When it was exhibited at the Paris Salon in 1863 Manet's *Picnic* (of which a closely related watercolour is reproduced here) caused a scandal because of the subject-matter. 'A commonplace woman of the demi-monde, as naked as can be, shamelessly lolls between two dandies dressed to the teeth,' as one critic put it, going on to remark that 'this is a young man's practical joke, a shameful open sore not worth exhibiting this way.' Public outrage was probably increased by the visual trap set by the artist: the composition is based on an Italian Renaissance engraving by Marcantonio Raimondi after Raphael, a central figure in the great European tradition that was still recommended as a source for study to aspiring painters. Much larger than the average Impressionist canvas, *The Picnic* was inspired by the sight of women bathing in the Seine at Argenteuil. Victorine Meurent, Manet's brother Gustave and the Dutch sculptor Ferdinand Leenhoff were the models.

Like Manet, Degas was an artistic conservative. In the late 1850s and early 1860s he concentrated on portraits and on Biblical, classical and historical subjects. It was only in the mid-1860s that he became really absorbed in themes of modern life. He was by far the greatest draughtsman among the Impressionists, capable of turning from a classically controlled study of the nude to the kind of brilliant notation revealed in this sheet of studies, which is usually related to the spectators sitting in the stand and on the grass in *The False Start* (Plate 57).

12. Edgar Degas (1834–1917): *Sheet of Studies*. About 1869–72. Brush and wash, gouache and *essence* (oil thinned with turpentine), 46 × 32.5 cm. (18⅛ × 12¾ in.) Paris, Louvre (Cabinet des Dessins)

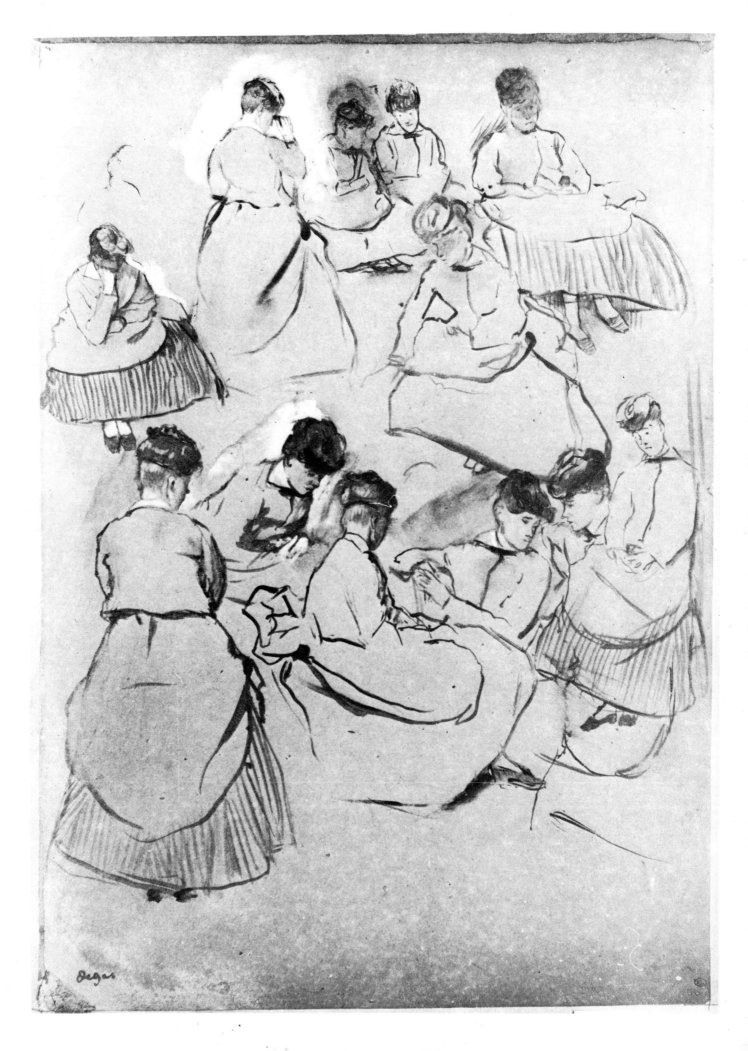

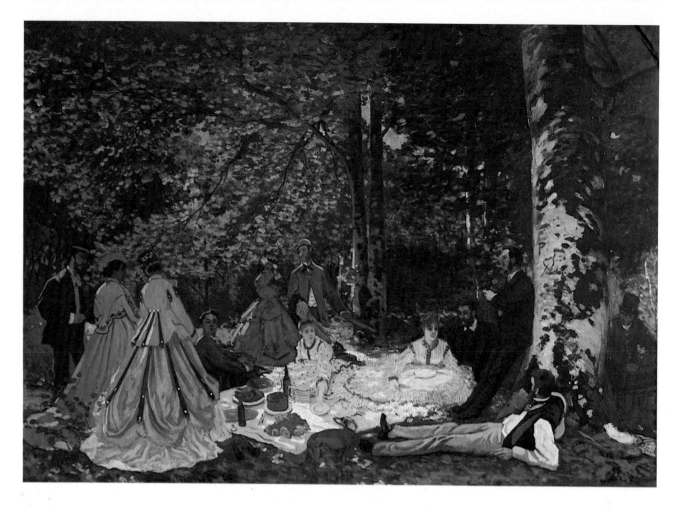

13. Claude Monet (1840–1926): *The Picnic* (*Le Déjeuner sur l'Herbe*). Signed and dated 1866. Canvas, 130 × 181 cm. (51¼ × 70 in.) Moscow, Pushkin Museum

The Picnic is an elaborate and fully worked out study for a huge canvas (roughly 15 × 20 feet) begun in Paris in the autumn of 1865 but abandoned, unfinished, in the following spring. Only two fragments now survive, both in Paris (Louvre and Private Collection). Monet was inspired to paint what would have been the most important work of his youth by Manet's *Picnic* (Plate 11). The differences are significant. Monet's response to light is keener, his touch—as a means of recording his optical impressions—is sharper and more fragmented. Approach the Moscow *Picnic* closely and it dissolves into a mass of colourful strokes. Although Impressionism is now regarded as—and was originally criticized for being—markedly democratic in theme and mood, and although Monet, like Renoir, was often very poor in the 1860s, *The Picnic* represents a decidedly middle-class event, complete with coachman to open the hamper (on the extreme right). The setting of *The Picnic* was painted at Chailly in the Forest of Fontainebleau, a favourite subject of the Barbizon painters and the Impressionists in the early 1860s. Later they came to prefer the villages, restaurants, bathing establishments and landscape along the banks of the Seine on the outskirts of Paris (see Plates 14, 31 and 51).

The Seine at Bougival (right) is a masterly example of Monet's developed style, in which the most rigorous observation of light effects is combined with a subtle feeling for composition and the purely *pictorial* relationship of colours, set down one beside another.

20

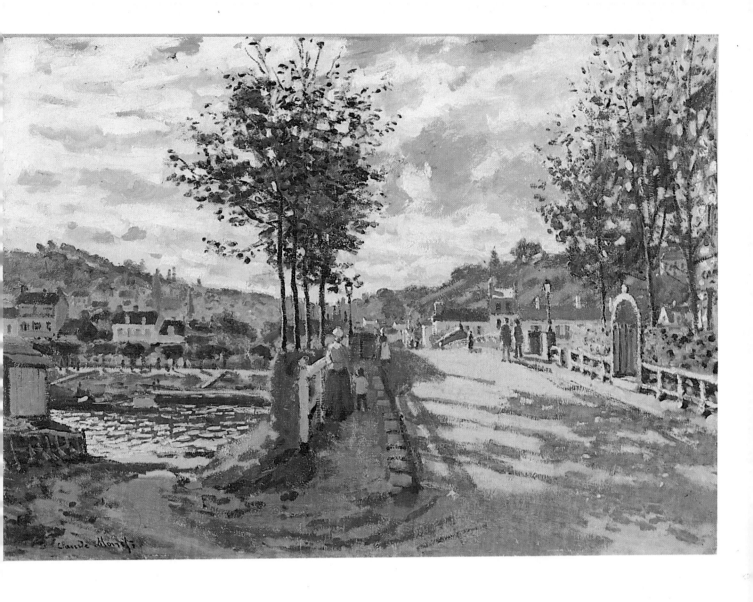

14. Claude Monet (1840–1926): *The Seine at Bougival*. About 1869. Signed. Canvas, 65.4 × 92.4 cm. (25¾ × 36⅜ in.)
Manchester, New Hampshire, Currier Gallery of Art

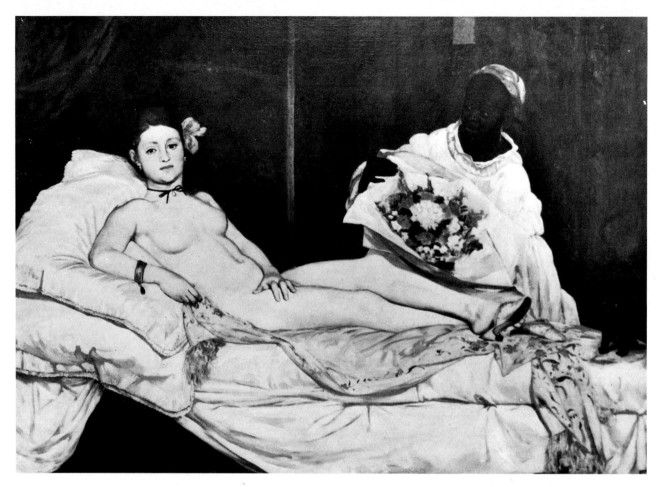

15. Edouard Manet (1832–83): *Olympia*. 1863. Canvas, 130.2 × 190 cm. (51¼ × 74¾ in.) Paris, Louvre (Jeu de Paume)

Of all the Impressionists, Edouard Manet was artistically the most conservative. He was influenced by Spanish masters like Velasquez and Goya and by the mid-nineteenth-century Realists such as Courbet. *Olympia*, in spite of being based on Titian's revered *Venus of Urbino*, which Manet had copied in Florence in the 1850s, caused a scandal when it was shown at the Paris Salon in 1865. One critic described how 'an epidemic of crazy laughter prevails . . . in front of the canvases by Manet. . . . [It is] a subject of general surprise that the jury accepted these works.' Another, Jules Claretie, was even harsher: 'What is this Odalisque with a yellow stomach, a base model picked up I know not where, who represents Olympia? Olympia? What Olympia? A courtesan no doubt.' The fundamental objection to *Olympia* was its unidealized character, the bold, challenging gaze of the model and unglamorized treatment of the female body.

In the meantime, Manet had begun to experiment with scenes taken directly from contemporary life. *Music in the Tuileries Gardens* is the first of his wholly successful works in this vein and was influential for the development of the other Impressionists. The tonality, with its buffs, blacks, greys and dirty greens, is still rather Spanish, but the bold modelling of all the forms and the studied casualness of the composition are characteristically Impressionist. Many of the main figures are actually portraits of Manet's friends and acquaintances. The painter himself is on the extreme left of this detail.

16. Edouard Manet (1832–83): *Music in the Tuileries Gardens* (detail). Signed and dated 1862. 76 × 118 cm. (30 × 46½ in.) London, National Gallery

22

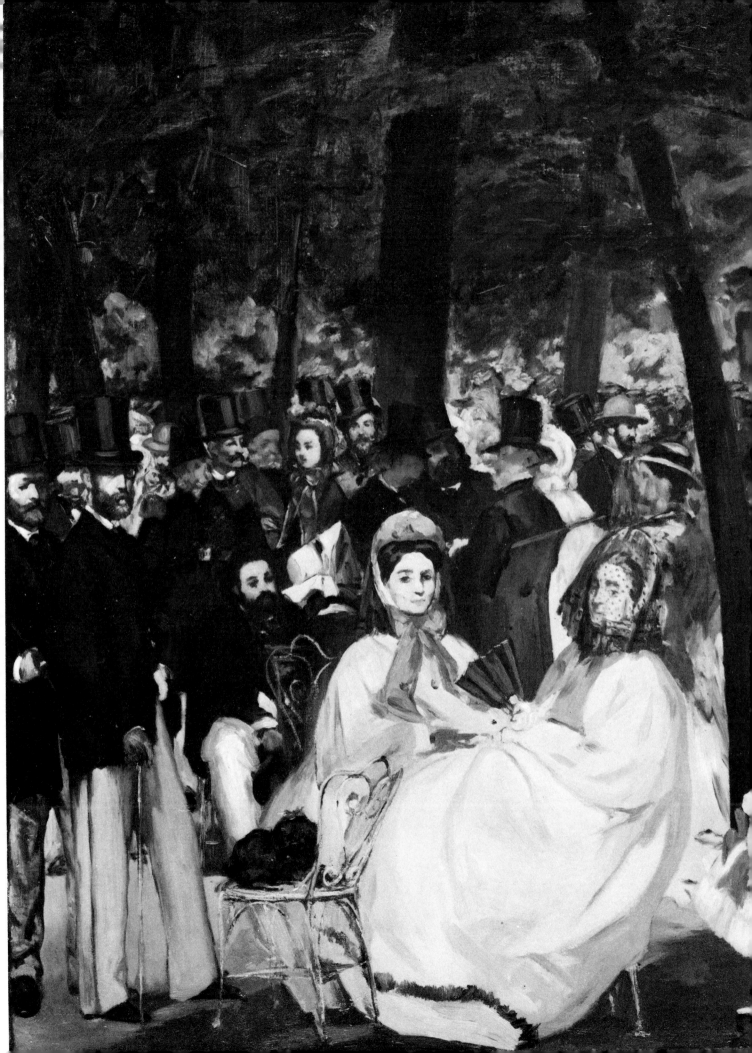

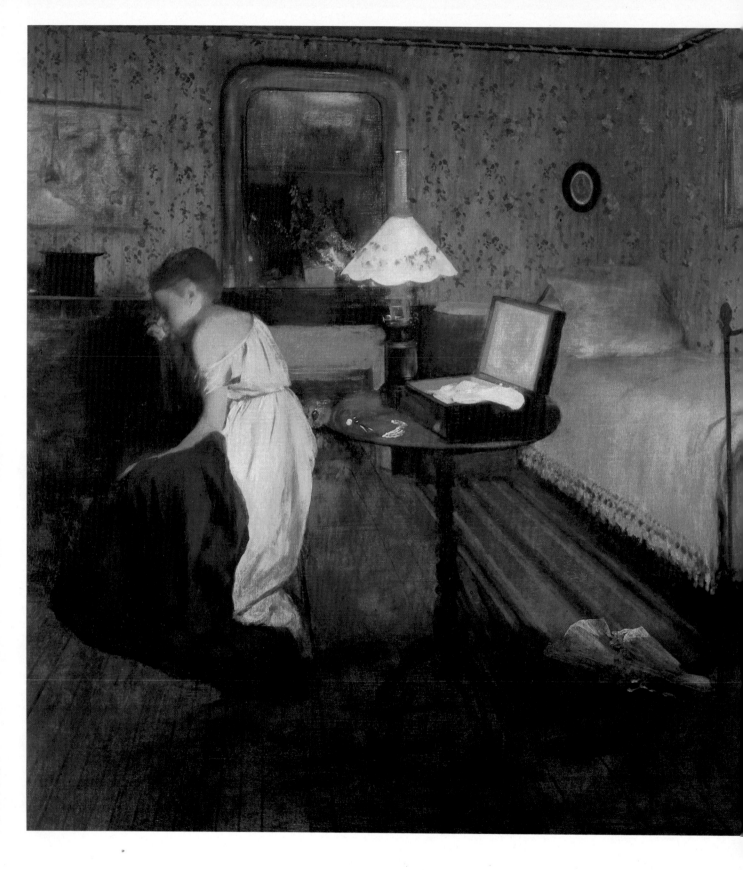

17. Edgar Degas (1834–1917): *Interior* ('*The Rape*'). 1868–9. Canvas, 81.3 × 114.4 cm. (32 × 45 in.) Philadelphia, Henry P. McIlhenny

24

The *Interior* is the most important of Degas's narrative paintings and one of which he was especially fond. He always referred to it either as *Interior* or 'my genre painting' and refused to reveal its meaning, which has been the subject of a great deal of speculation and guesswork. Theodore Reff is almost certainly right in identifying it as an illustration of an episode in Zola's famous realistic novel, *Thérèse Raquin* (1867): the terrible wedding night of Thérèse and her lover, Laurent, who has in fact murdered her first husband a year earlier. Their tormented consciences, however, have already begun to destroy their passionate relationship. What attracted Degas to this particular scene was, perhaps, the visual possibilities of high drama—but high drama in which everything remains bottled up. Hence the visual mood of tension and ambivalence. Although Degas has achieved, in the composition, a kind of studied casualness, with the main figures pushed to the sides, there was nothing in the least casual about his approach. Several oil sketches and drawings survive, sometimes with written reminders about a point of colour or tone or visual emphasis. Two of the studies from one of his notebooks are reproduced overleaf (Plates 19 and 20).

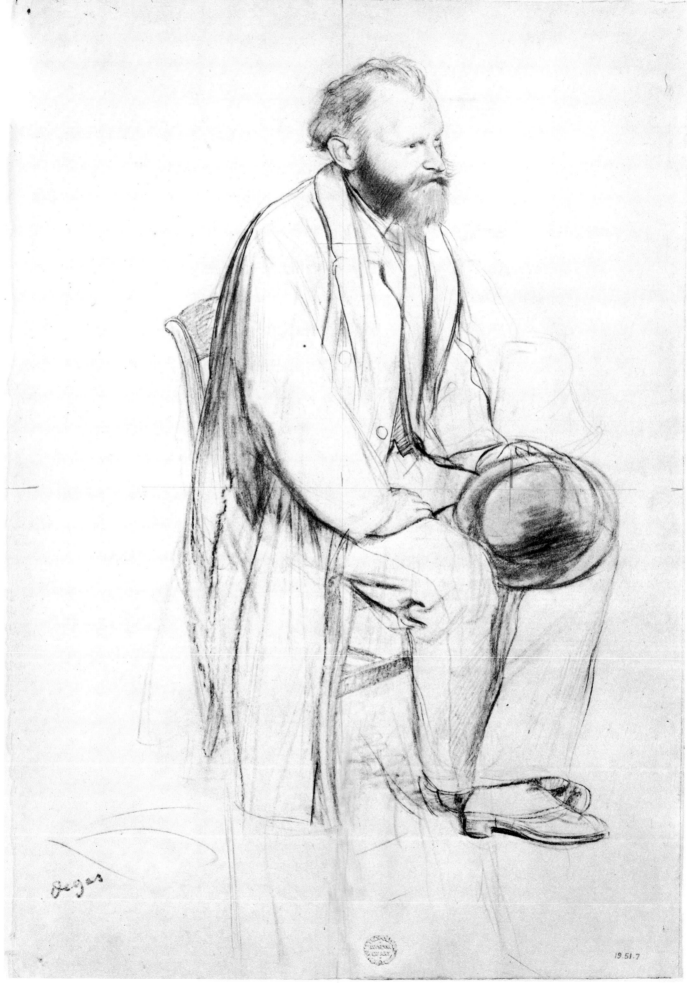

Degas

19 and 20. Edgar Degas (1834–1917): *Two Studies for 'The Interior'*. 1868–9. Pencil, 19 × 23.6 cm. (7½ × 9¼ in.) Paris, Bibliothèque Nationale (Reff, Note-book 22)

Degas and Manet are supposed to have met in the Louvre in the early 1860s when they were copying the Old Masters. Manet's art (Plates 9, 11 and 16) was an important influence on Degas at a time when he was becoming disillusioned with conventional, academic subject-matter. The beautiful study on the left was made in preparation for an etched portrait, which is in fact rather less expressive.

Left: 18. Edgar Degas (1834–1917): *Study for a Portrait of Manet*. About 1864. Black chalk and *estompe*, 33 × 23 cm. (13 × 9⅛ in.) New York, Metropolitan Museum of Art

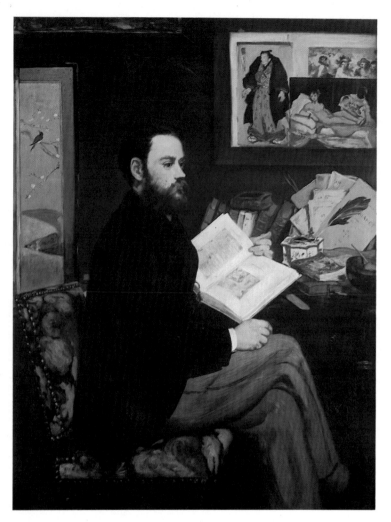

The great novelist, Emile Zola (1840-1902), was a staunch champion of Impressionism and wrote many enthusiastic articles on the painters and their new art. He met Manet in February, 1866, and soon wrote a laudatory piece on him; in gratitude, Manet painted this famous portrait, which was included in the 1868 Paris Salon, where its flat, rather simplified modelling shocked visitors. The screen on the left and the Utamaro print, upper right, symbolize the Impressionists' admiration for Japanese art, while the reproductions of Velasquez's *The Topers* and Manet's own *Olympia* (see Plate 15) specifically refer to Manet's taste and art.

Degas's beautiful picture of his friend and fellow painter, Tissot (for whom see note to Plate 42), is a comparable but more brilliant example of Impressionist portraiture. The pose of the figure, deliberately casual and slightly off-centre, the cutting of the three paintings in the room—left, top and right—and the placing of a small Cranach portrait dead centre on the wall are devices by which Degas creates the illusion of a 'slice of life'. The painting visible at the top is another allusion to Japanese art.

21. Edouard Manet (1832–83): *Portrait of Emile Zola.* Signed; 1867–8. Canvas, 146 × 114 cm. (57 × 43⅝ in.) Paris, Louvre (Jeu de Paume)

22. Edgar Degas (1834–1917): *Portrait of J. J. Tissot.* 1866–8. Signed. Canvas, 151 × 112 cm. (59½ × 44 in.) New York, Metropolitan Museum of Art

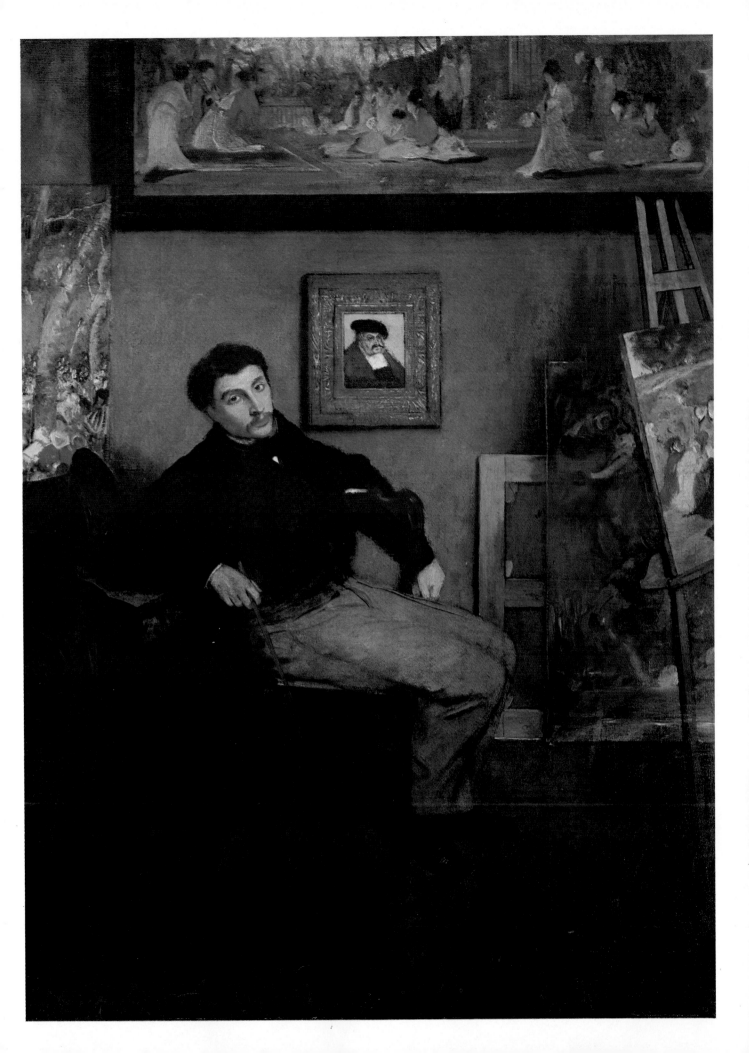

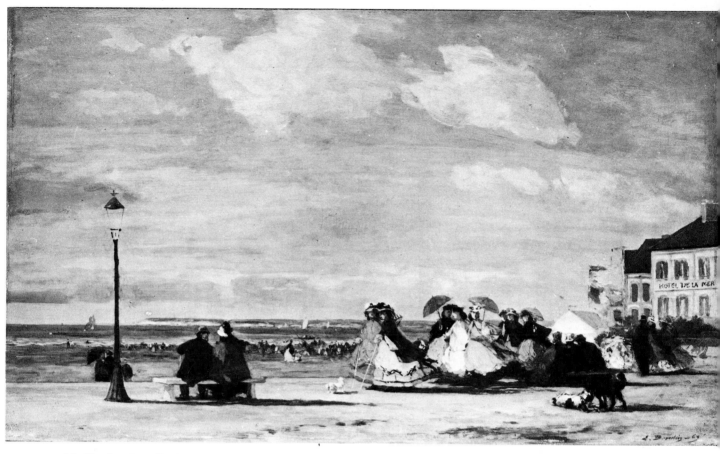

23. Eugène Boudin (1824–98): *The Beach at Trouville: the Empress Eugénie.* Signed and dated 1863. Panel, 34.3 × 57.8 cm. (13½ × 22¾ in.) Glasgow, Museum and Art Gallery (Burrell Loan)

24. Camille Pissarro (1830–1903): *The Donkey Ride near La Roche-Guyon.* Signed; about 1864–5. Canvas, 36 × 53 cm. (14¼ × 20⅞ in.) Formerly Basle, Robert von Hirsch

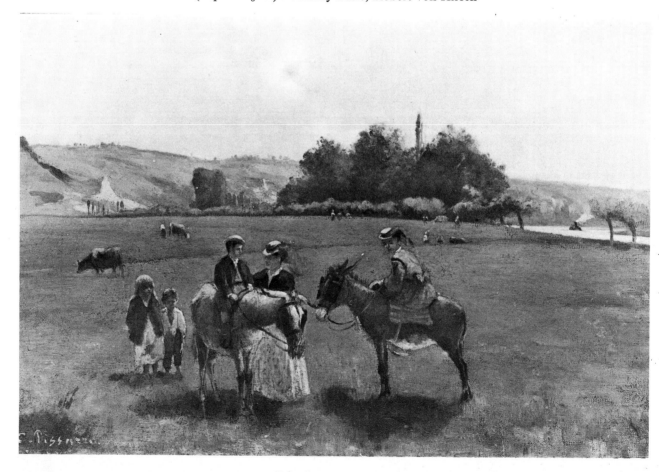

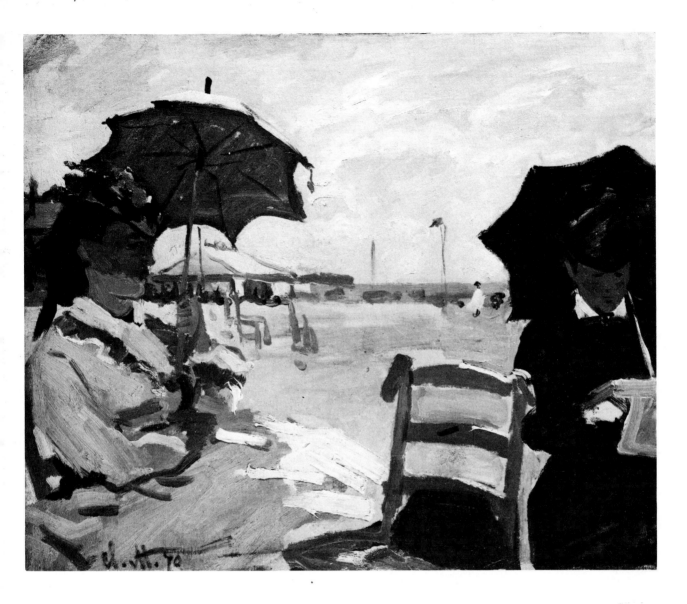

25. Claude Monet (1840–1926): *The Beach at Trouville*. Signed and dated 1870. Canvas, 38 × 46 cm. (15 × 18 in.) London, National Gallery

Boudin was a painter of the older generation who encouraged the young Monet to paint out-of-doors. *The Beach at Trouville*, which includes the figures of the Empress Eugénie and her suite out for a walk, is one of his most brilliant studies of the seaside and is full of light and air. Boudin always preferred working on a small scale and his handling of paint is apt to be rather timid—especially in comparison with Monet's picture of the same beach. This is one of his boldest 'snapshots' of figures in sunlight; and already his methods of achieving this effect, the juxtaposed strokes

of often thick pigment, have begun to take on a life of their own—a development that reaches its climax in his later water-lily pictures, in which colour and texture are as much *a part of what is seen* as the fronds and lilies that are the ostensive subject of the paintings.

Camille Pissarro was the most steadfast of the Impressionists; and he was both loved and revered for his firmness of purpose. *The Donkey Ride* is a fine example of his early work and reflects the serene influence of Corot and the Barbizon painters.

31

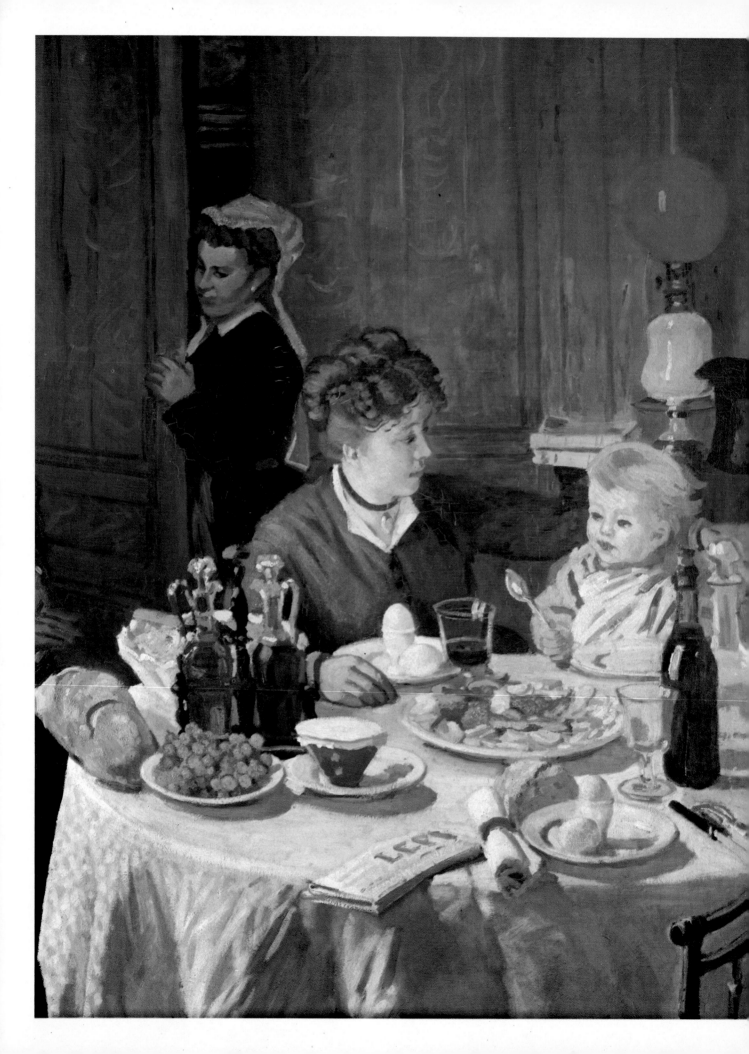

Although the Impressionists were committed, at least in theory, to the idea of impartially recording all aspects of life, most of their subject-matter is in fact markedly optimistic— as can be seen by looking through the plates in this book—and it is this optimism that partly explains their enormous and continuing popularity. Monet, for example, here makes of a perfectly ordinary scene an image that seems intensely joyous and somehow important. Pictures of war, famine, disease, death, exploitation and poverty are scarcely to be found among the works of the Impressionists. It is typical of Manet, however, with his strong sense of artistic tradition and admiration for artists like Goya, who had tackled difficult themes, that he should have painted *The Execution of the Emperor Maximilian of Mexico* (1867; Mannheim) and this episode from the last days of the Commune. The group of firing soldiers is of course based on Goya's *Third of May* (Madrid, Prado).

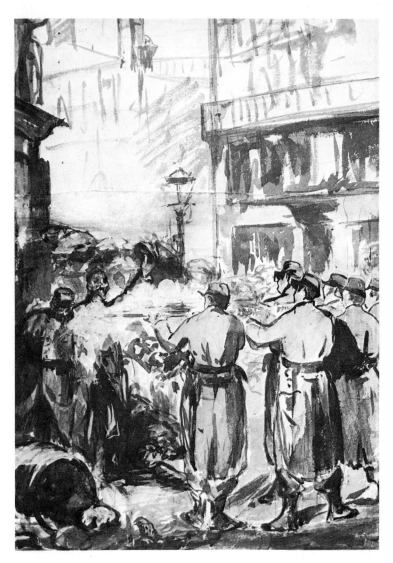

26. Claude Monet (1840–1926): *Luncheon* (detail). Signed and dated 1868. Canvas, 230 × 150 cm. (90 × 69 in.) Frankfurt, Städelsches Kunstinstitut

27. Edouard Manet (1832–83): *Civil War* or *The Barricades*. 1871. Ink wash and watercolour, 46 × 32.5 cm. (18$\frac{1}{8}$ × 12$\frac{3}{4}$ in.) Budapest, Museum of Fine Arts

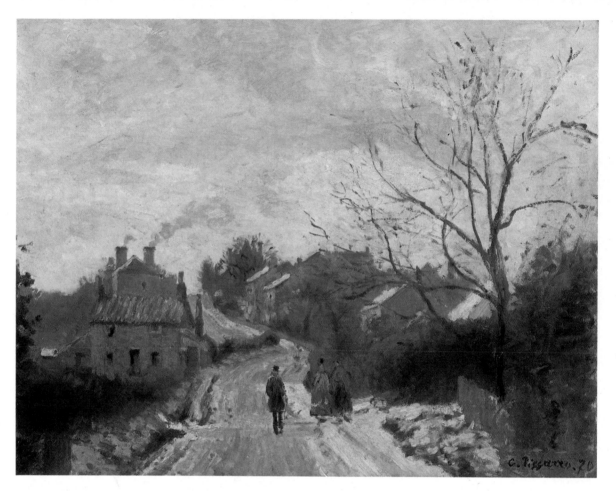

28. Camille Pissarro (1830–1903): *Lower Norwood under Snow.* Signed and dated 1870. Canvas, 35.3 × 45.7 cm. (13⅞ × 18 in.) London, National Gallery

The Impressionists were divided in their reaction to the Franco-Prussian War. Bazille and Degas, for example, served in the army; and Bazille was killed (see note to Plate 10). Both Monet and Pissarro, on the other hand, fled to England as refugees. Pissarro arrived in the autumn of 1870. He settled in the London suburb of Upper Norwood, an area with houses and large gardens not unlike the outskirts of Paris from which he had fled. *Lower Norwood under Snow* is small in scale and modest in character, like the pictures of Corot that Pissarro so admired; but the response to weather conditions is more adventurous and in a sense more honest than that of Corot, who never once painted a winter landscape.

Alfred Sisley came from a well-to-do English family living in Paris; and he studied in the studio of Gleyre, where he met Monet, Renoir and Bazille. His art is the most even-tempered and restricted of the Impressionists; he produced virtually nothing but landscapes, usually scenes from the still rural suburbs round Paris. The picture reproduced on the right is among his finest, with a sharpness of observation, richness of colour and liveliness of touch that he seldom equalled. After the Franco-Prussian War, which ruined his father's business, Sisley was never again in easy circumstances, but he did not waiver in his love of landscape.

29. Alfred Sisley (1839–99): *The Bridge at Villeneuve-la-Garenne* (detail of Plate 30). Signed and dated 1872. Canvas, 49.5 × 65.4 cm. (19½ × 25¾ in.) New York, Metropolitan Museum of Art (Gift of Mr & Mrs Henry Ittleson, Jr, 1964)

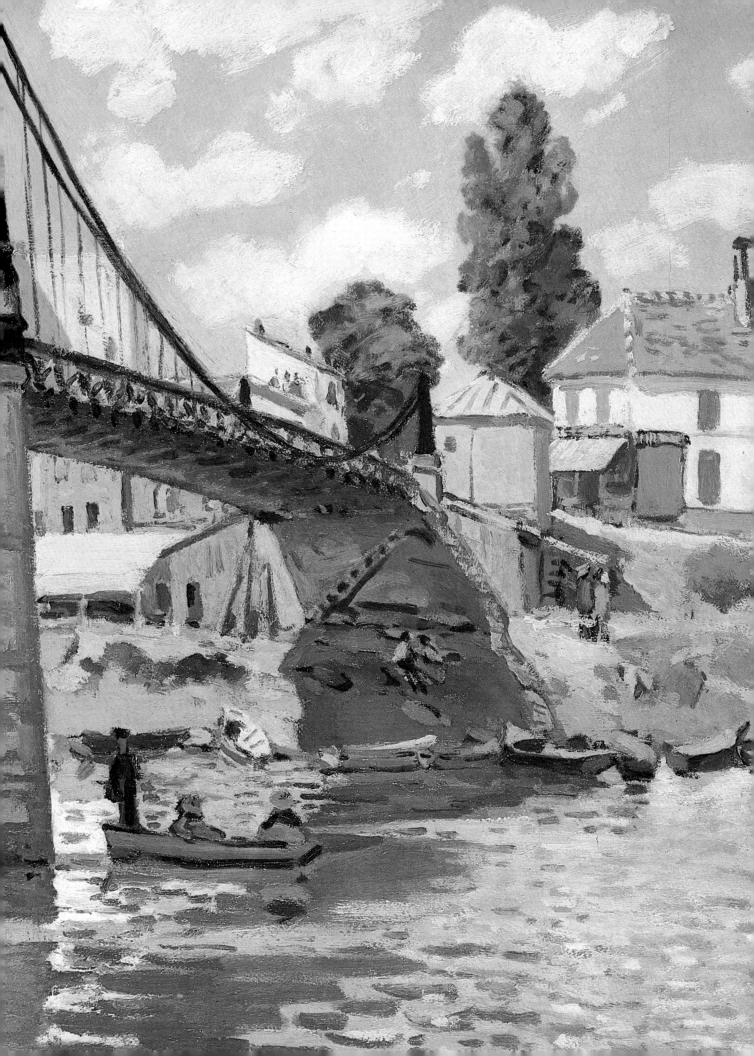

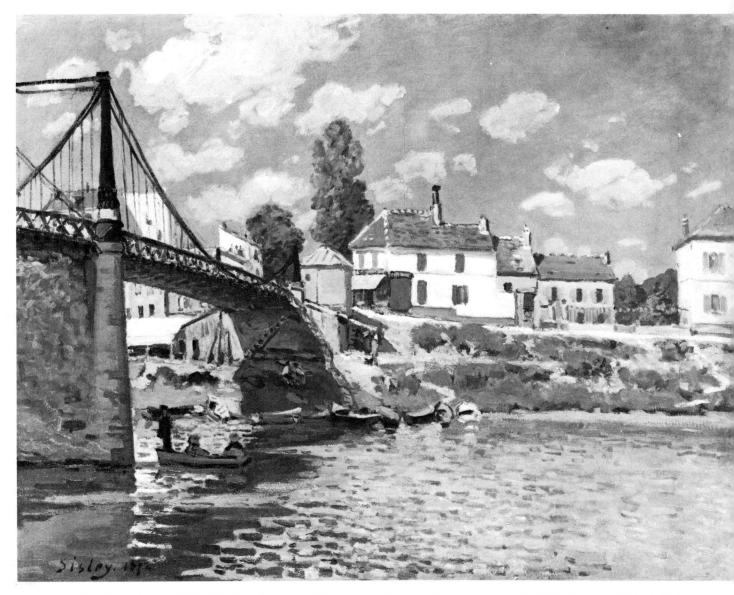

30. Alfred Sisley (1839–99) *The Bridge at Villeneuve-la-Garenne*. Signed and dated 1872. Canvas, 49.5 × 65.4 cm. (19½ × 25¾ in.) New York, Metropolitan Museum of Art (Gift of Mr & Mrs Henry Ittleson, Jr, 1964)

The Impressionists soon learned that painting landscape direct from the motif, instead of working up pictures in the studio from sketches in the traditional way, presented all kinds of problems. Manet, for example, painted his view up the Rue de Berne from a first-floor window (Plate 36), undistracted by the spectators who would have gathered round him had he set up his easel on the pavement. In Plate 31 Monet is shown working in his special studio-boat, which enabled him to move up and down the Seine and change his subject-matter with ease. Although very different in character and outlook, Manet had great admiration for Monet's ability and tenacity; and it was mainly due to Monet's example that he, too, began to paint out-of-doors in the summer of 1874.

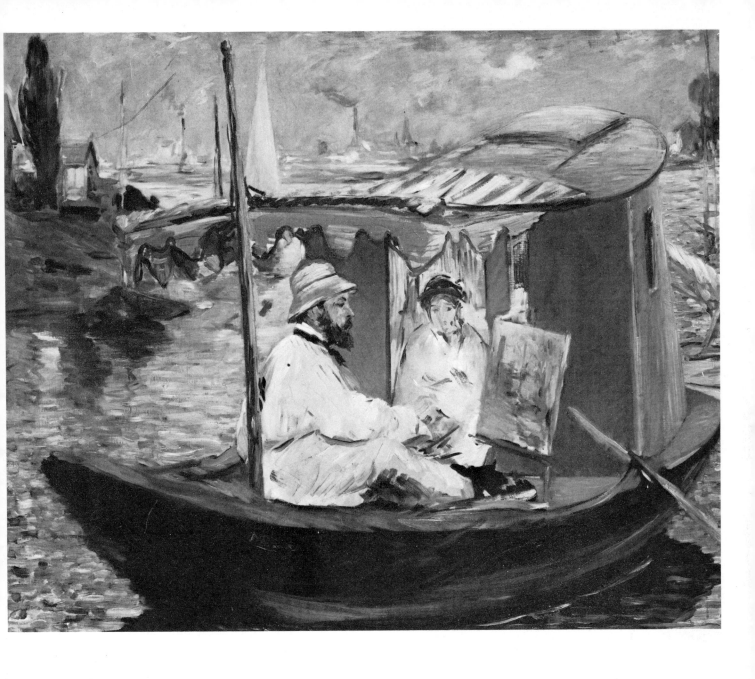

31. Edouard Manet (1832–83): *Claude Monet in his Floating Studio*. 1874. Canvas, 80 × 97.8 cm. (31½ × 38½ in.)
Munich, Neue Staatsgalerie

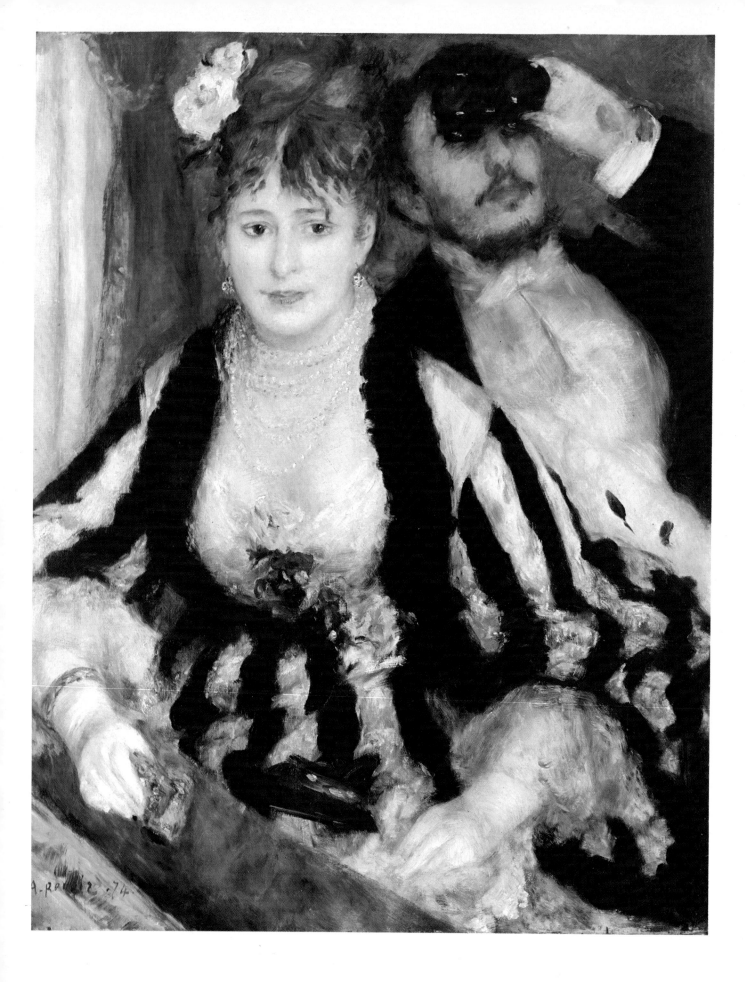

The theatre was always a popular subject with the Impressionists (and Post-Impressionists like Seurat and Toulouse-Lautrec). It offered colour, variety, unexpected angles and unusual light sources, glamour and excitement, and a milieu in which art and life, so to say, clashed head on. The sheer artifice of 'theatre' (plays, opera and, above all, ballet) always appealed to Degas because it gave him ample opportunities to observe professionals going through rituals and routines, precisely calculated disciplines, for professional rather than personal reasons. As in the painting on the right, he preserves ballet's artifice but strips away the pretence, so that what we see are professional dancers caught in mid-performance rather than the magical charm of ballet.

Renoir's instincts were more conventional and also more generous. He adored pretty girls, with or without clothes, and unlike Degas took an optimistic view of human relations. *The Boatmen's Lunch* (Plate 51) is a visual hymn to youth and love, just as *The Box*, one of his greatest masterpieces, conveys the sheer pleasure of life. In spite of Impressionist devices—such as half concealing the man's face behind his opera glasses—the painting is also a tribute to beauty—in this case the Montmartre model known as Nini. The man is the artist's brother, Edmond Renoir.

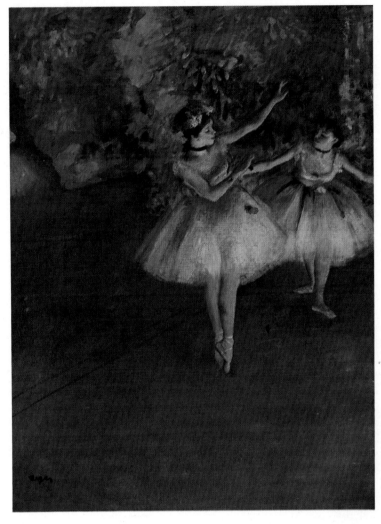

32. Pierre-Auguste Renoir (1841–1919): *The Box* (*La Loge*). Signed and dated 1874. Canvas, 80 × 64 cm. (31½ × 25 in.) London, Courtauld Institute Galleries

33. Edgar Degas (1834–1917): *Dancers on the Stage.* Signed; 1874. Canvas, 62 × 46 cm. (24½ × 18¼ in.) London, Courtauld Institute Galleries

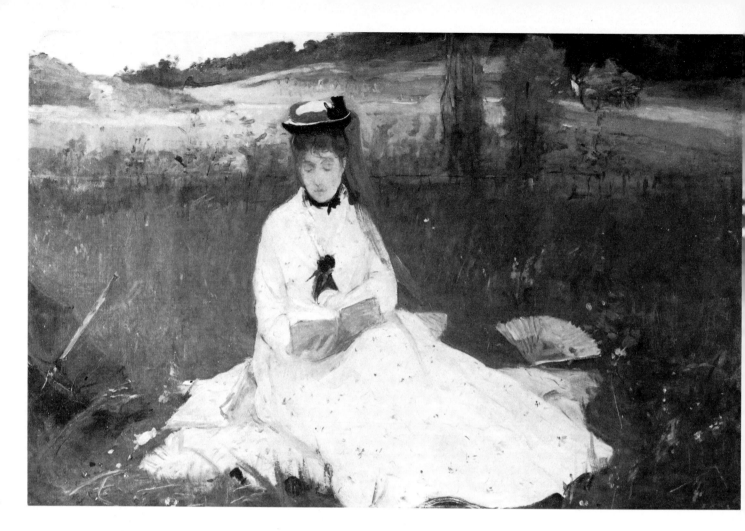

34. Berthe Morisot (1841–95): *The Artist's Sister, Mme Pontillon, seated on the Grass*. Signed and dated 1873. Canvas, 45.1 × 72.4 cm. (17¾ × 28½ in.) Cleveland Museum of Art (Gift of the Hanna Fund)

Berthe Morisot was a minor though talented member of the Impressionist group who, in spite of a conventional and extremely comfortable upper middle-class background, was determined to become a painter. After studying with a number of artists, including Corot, she exhibited at the Salon for the first time in 1864. It was in 1868 that she first met Manet, who exerted a considerable influence on her painting. She also became a personal friend and posed for him. This charming study of her sister shows Manet's influence fairly clearly, particularly in the handling of the paint. Note the 'casually' placed parasol and fan.

Guillaumin was another minor luminary in the Impressionist firmament. Employed in business, and then as a civil servant, he was for long only a Sunday painter; but in 1859 he began to take classes at the Académie Suisse, one of the rallying points of embryonic Impressionism, where he met Pissarro, Monet and Cézanne. He exhibited with the group in their historic first show at the premises of the photographer Nadar in 1874. His earlier paintings are decidedly his best. This one is of interest in showing the corner of a typical Parisian studio, replete with oil sketches and the (by then) almost obligatory Japanese fan, stuck behind the plate.

35. Armand Guillaumin (1841–1927): *Pissarro's Friend, Martinez, in Guillaumin's Studio*. 1878. Canvas, 90.2 × 74.9 cm. (35½ × 29½ in.) Upperville, Virginia, Mr & Mrs Paul Mellon

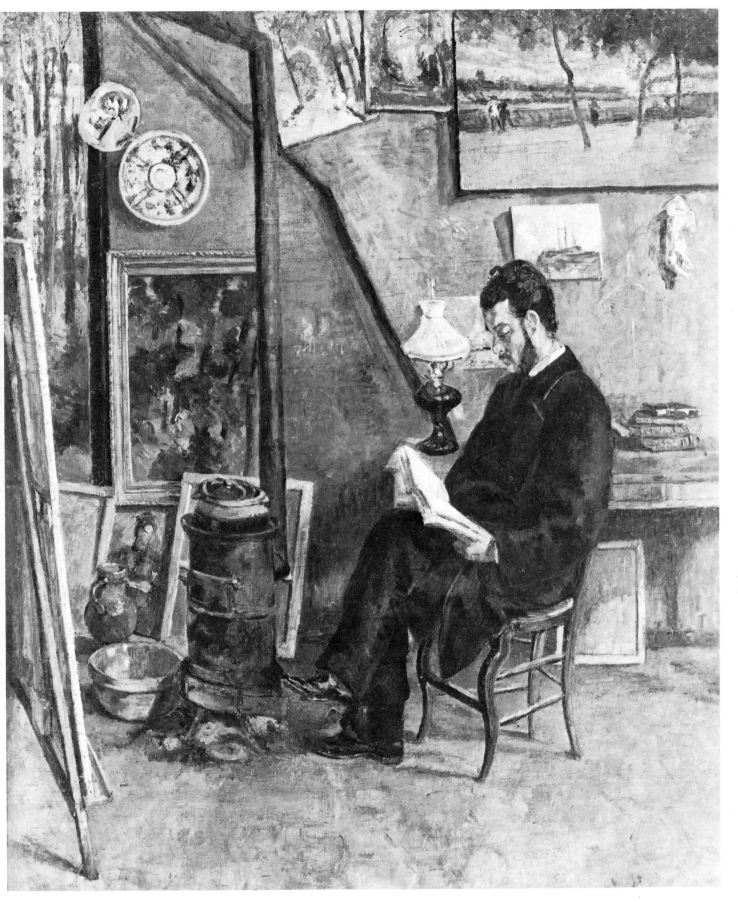

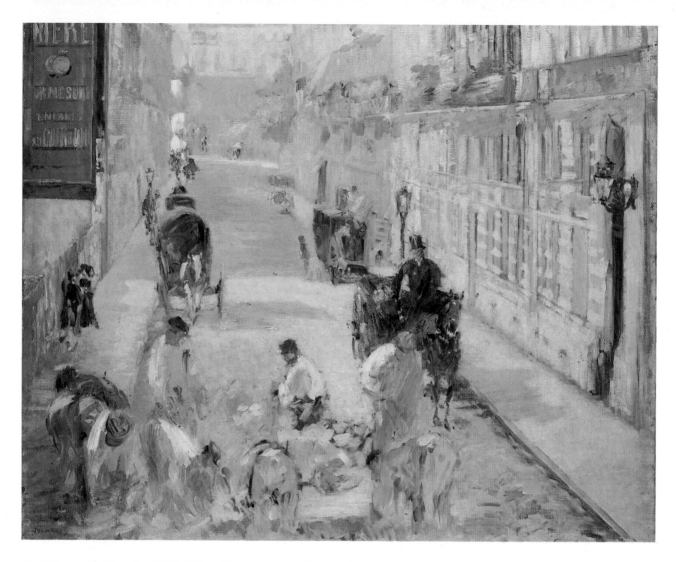

36. Edouard Manet (1832–83): *The Road-menders, Rue de Berne*. 1878. Canvas, 63.5 × 80 cm. (25 × 31½ in.) England, Private Collection

The Road-menders, Rue de Berne, which shows the view from a first-floor window of Manet's Paris studio, is among the finest of his purely Impressionist paintings—accurate and convincing in its response to effects of light and atmosphere yet handled with his habitually silky smoothness of touch.

Like *The Box* (Plate 32), *La Parisienne* was exhibited at the first Impressionist group exhibition in 1874; and confronted, now, by such joyous and enchanting pictures it becomes harder than ever to understand the violent and hysterical reaction that the Impressionists originally provoked. Perhaps the very simplicity of the style was at the heart of the criticism: it was an art without padding or subterfuge. It was also an art often about and largely by youth—something that always makes the middle-class and the middle-aged uneasy, as we have seen in our own time in the case of John Osborne. The idea of an absolutely plain background in *La Parisienne*—as featureless as the roll of white paper on which fashion models stand—was borrowed from Manet, who in turn took it from the work of the great Spanish painter who was one of his idols, Velasquez.

37. Pierre-Auguste Renoir (1841–1919): *La Parisienne*. Signed and dated 1874. Canvas, 160 × 105 cm. (63 × 41½ in.) Cardiff, National Museum of Wales (Gwendoline E. Davies Bequest)

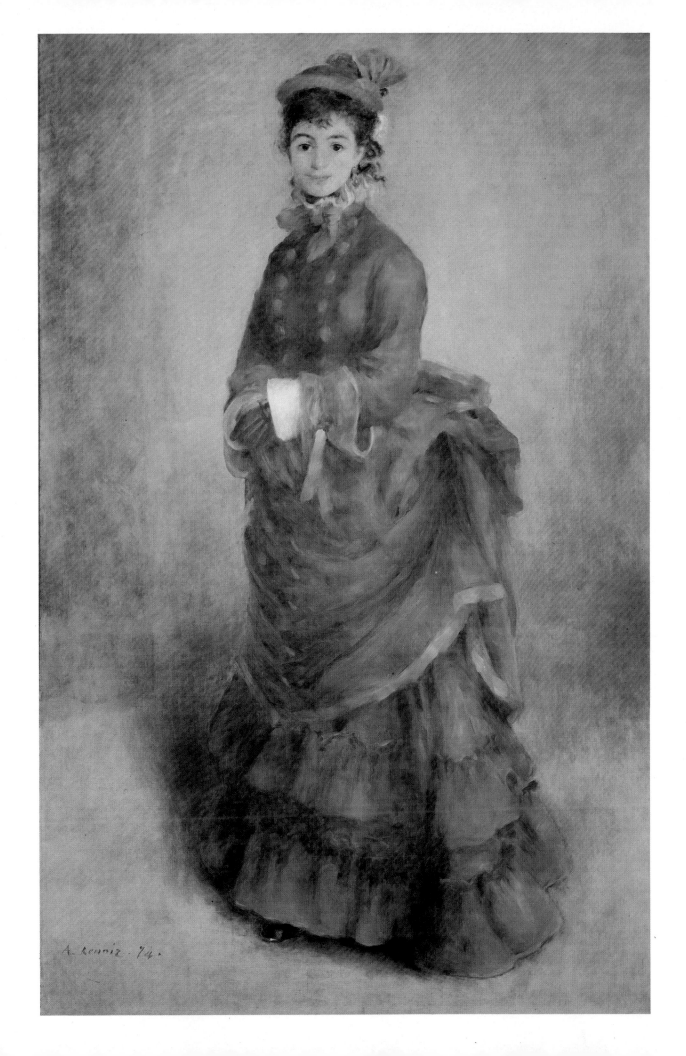

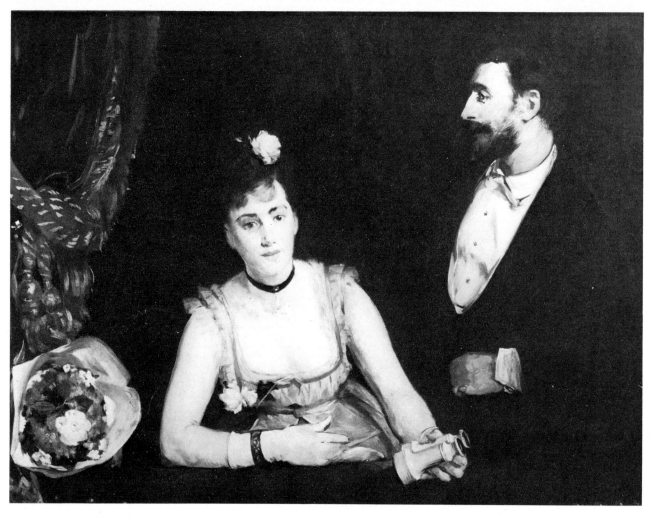

38. Eva Gonzalès (1849–83): *A Box at the Théâtre des Italiens*. Signed; about 1874. Canvas, 98 × 130 cm. (38⅝ × 51¼ in.) Paris, Louvre (Jeu de Paume)

Eva Gonzalès was another of Manet's protégés, who had been trained by a fashionable painter named Chaplin before meeting him in 1869. She modelled for Manet and, like Berthe Morisot, was heavily influenced by his style, as this painting shows. It was rejected by the Salon jury in 1874, but accepted when she submitted it again in 1879—one of many indications of the gradual thawing of official attitudes towards Impressionism. Another was Renoir's sudden success as a society portrait painter, which came with the exhibition, at the same Salon of 1879, of his large group portrait of Madame Charpentier and her children (Metropolitan Museum, New York).

The Impressionists had always used each other as free models for individual studies and genre scenes such as *The Boatmen's Lunch* (Plate 51) or Monet's *Picnic* (Plate 13). In this sensitive study of Monet, note the calculated informality of the pose, the visual suggestion that the sitter is unaware of being painted as he concentrates on his book and puffs away at his pipe. Figures smoking occur in many Impressionist pictures—another mark of informal naturalism that would have been frowned on by traditional portrait painters.

39. Pierre-Auguste Renoir (1841–1919): *Portrait of Claude Monet*. Signed; 1872. Canvas, 61.6 × 50.2 cm. (24¼ × 19¾ in.) Washington, D.C., Paul Mellon Coll.

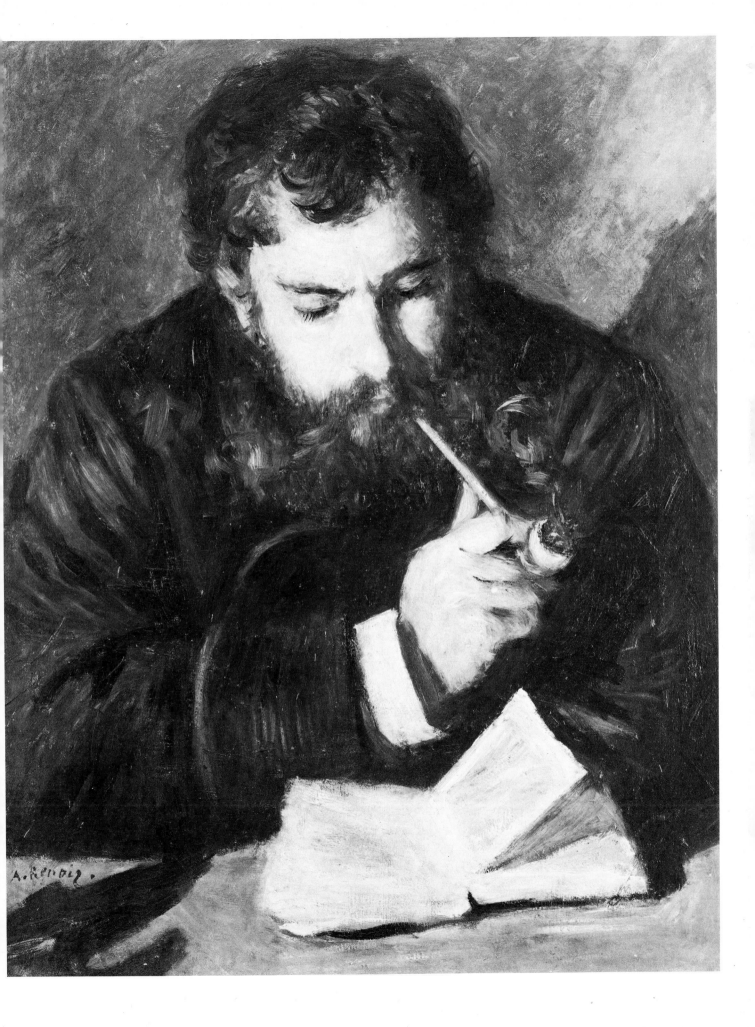

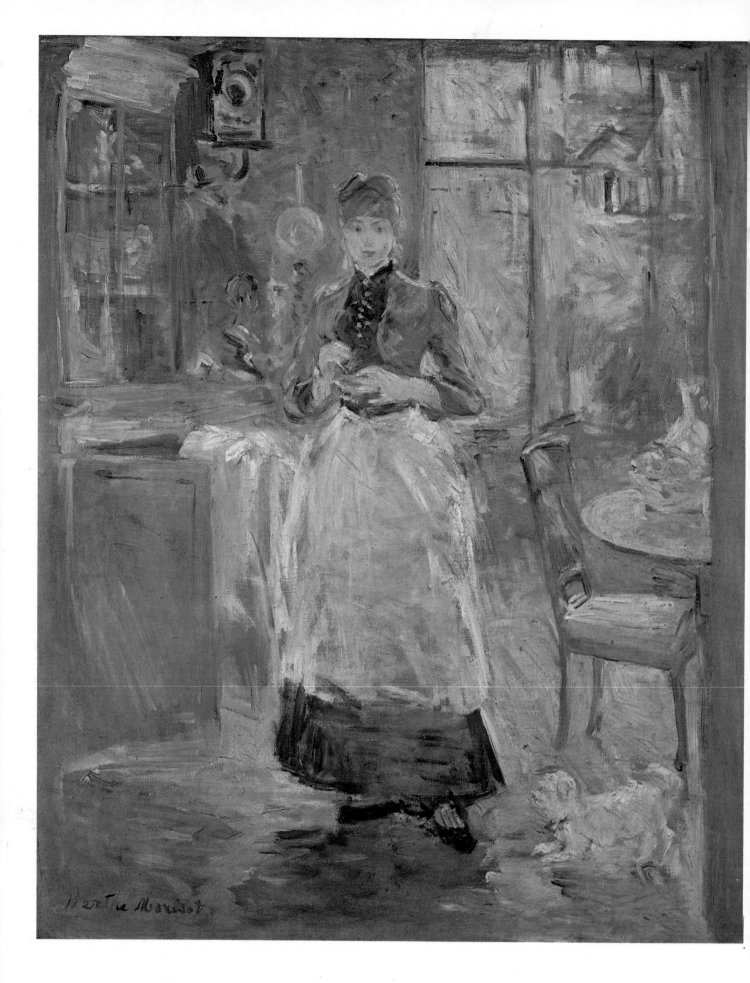

In the Dining Room shows Berthe Morisot's art at its best—light, easy, unpretentious and both delicate and affectionate (see also Plate 34).

Renoir was one of the greatest masters of the female nude in European painting; he combined an almost intuitive knowledge of the poses and angles at which the female body looks its most alluring with a virtuoso ability to suggest the skin's glowing translucence. The *Female Nude*, which depicts a Montmartre model named Anna whom Renoir painted several times during 1876, is one of any number of paintings by the Impressionists that contradict the popular idea of Impressionism as naturalistic. In its erotic glamour, its colour, its careful manipulation of the body to achieve a satisfying but basically rather artificial pose, the painting is as remote from life as a Titian or a Rubens. The comparison with Degas in this respect is revealing: Degas, whose attitude towards women was ambivalent, keeps his distance. His nudes (Plate 65) seldom if ever look towards the spectator, thus strengthening the illusion that we are watching them unobserved. Whereas Renoir's beautiful girls are as prepared for admiration as any goddess of mythology.

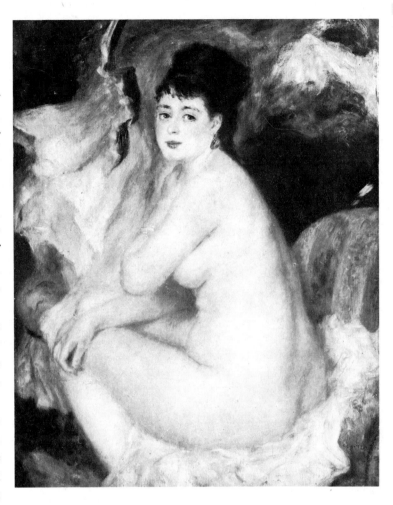

40. Berthe Morisot (1841–95): *In the Dining Room.* Signed; about 1886. Canvas, 61.3 × 50 cm. (24⅛ × 19¾ in.) Washington, D.C., National Gallery of Art (Chester Dale Collection)

41. Pierre-Auguste Renoir (1841–1919): *Female Nude.* Signed and dated 1876. Canvas, 92 × 73 cm. (36¼ × 28¾ in.) Moscow, Pushkin Museum

42 and 43. Jacques-Joseph (James) Tissot (1836–1902): *The Henley Regatta of 1877*. 1877. Canvas, 46 × 95 cm. (18½ × 38 in.) Henley, England, The Leander Club

Tissot is an extremely interesting artist who touches Impressionism at many points without ever exactly becoming a fully-fledged Impressionist. He came from Nantes and began to study in Paris about 1856. He worked with the classicizing painters, Flandrin and Lamothe, in whose studio he became friendly with Degas. He was always deeply attracted by the Old Masters and produced a number of historicizing scenes in the vein of Henri Leys, the Belgian history painter. Tissot had begun showing at the Paris Salon in 1859; and from 1864 he also exhibited regularly at the Royal Academy in London. The political events of 1870 drove him to England, where he lived and, in the early 1870s, enjoyed great success. Degas, who had painted his portrait (see Plate 22), was in correspondence with him but Tissot declined an invitation to participate in the first Impressionist group exhibition in 1874. Although he was fond of the same kind of informal subject-matter as the Impressionists, and used many of their pictorial devices, such as allowing the edge of the composition to cut off parts of figures (as here, lower left), Tissot always preferred a higher degree of finish than Degas or Manet; and his view of society and social events (evident in *Too Early*, 1873 [London, Guildhall], or the Tate Gallery's *Ball on Shipboard* of 1874) is essentially that of a fellow guest rather than a dispassionate observer. *The Henley Regatta* is his most important landscape, painted, for once, with an Impressionist freedom of touch.

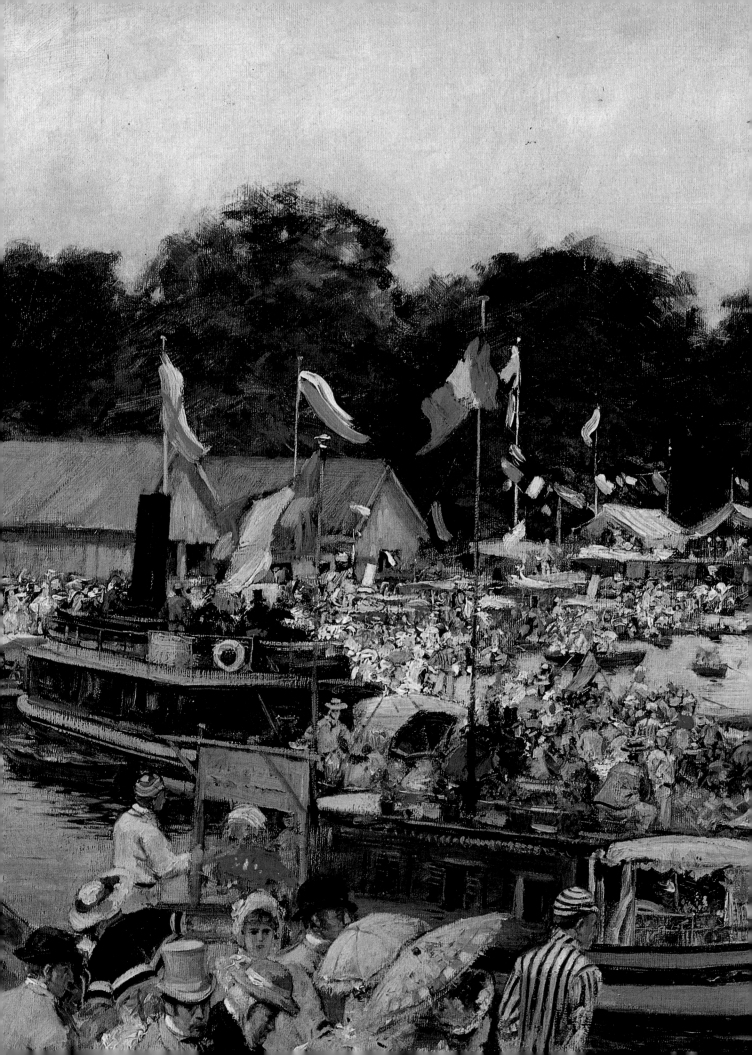

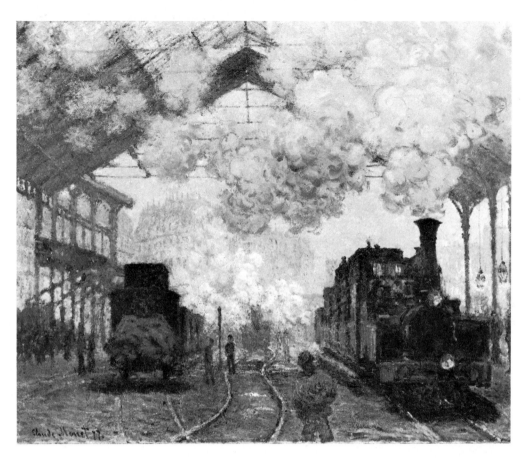

44. Claude Monet (1840–1926): *La Gare Saint-Lazare.* Signed and dated 1877. Canvas, 82 × 101 cm. (32⅜ × 39¾ in.) Cambridge, Mass., Fogg Art Museum

Monet's habit of painting on the spot, directly in front of the subject, led him to develop the idea of the series, a set of pictures of the same motif, from slightly different angles and, more important still, under different lighting and weather conditions. The series devoted to the Parisian railway station, the Gare Saint-Lazare, is among the most splendid; the theme is also uncompromisingly modern. Railways were not considered suitable subjects for 'poetic landscape' and do not feature, for example, in the works of Corot.

Seurat belongs to the next generation of painters, but two of his works are included here because they illustrate the transition from Impressionism to Post-Impressionism. *The Bathers, Asnières* was Seurat's first major work. The subject-matter, a bathing place on the Seine outside Paris, is quintessentially Impressionist. So is the feeling for sunlight

and its impact on forms and colours; but the actual style is not. Seurat, like Cézanne, was worried by the apparent formlessness of the classic Impressionist technique, with its fondness for blobs of pure colour, and set about rationalizing its method. The oil sketches for *The Bathers* (upper right) still retain an Impressionist freedom of touch; but the finished painting (right) is monumental in its orderliness and gravity—one can appreciate its qualities even more by comparing it, for example, with Renoir's *Boatmen's Lunch* (Plate 51). Seurat has retained the virtues of Impressionism, its feeling for light and colour and truth to appearances, its democratic subject-matter and celebration of humble pleasures, and given them greater clarity and weight. A common reaction in front of *The Bathers* is to be reminded of the Renaissance frescoes of Piero della Francesca.

50

45. Georges-Pierre Seurat (1859–91): *Study for 'The Bathers, Asnières'*. 1883. Panel, 15 × 25 cm. (6 × 9¾ in.)
National Gallery, London (loan)

46. Georges-Pierre Seurat (1859–91): *The Bathers, Asnières*. 1883–4. Canvas, 201 × 300 cm. (79⅛ × 118⅛ in.)
London, National Gallery

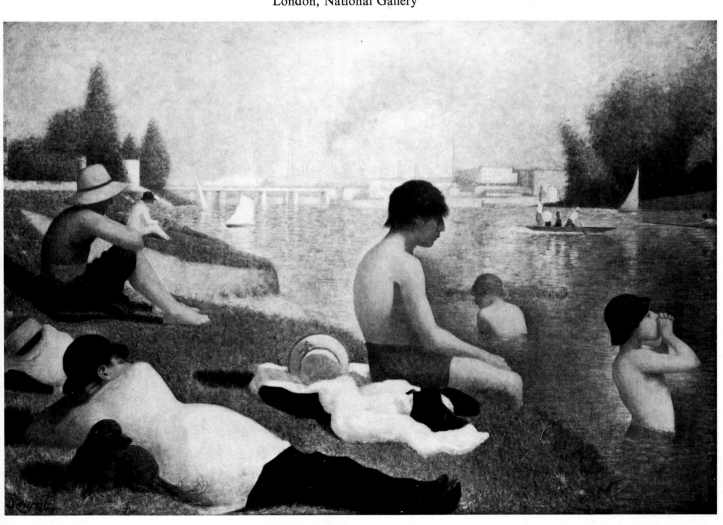

Degas was a tireless observer and recorder of the small change of visual experience, the everyday detail of ordinary life: a man smoking a cigar, the set of a woman's body as she ironed clothes (Plate 64) or stood in contemplation of a masterpiece in a museum. And he knew how to make the most of his observations, how to isolate them visually. The gesture of a woman easing on her glove is the focus of attention in the painting reproduced above, psychologically and pictorially. The suggestion of an open door, of a woman glimpsed from a distance, unobserved, was a device Degas often used to heighten the naturalistic illusion. The subject of the painting on the right was never precisely known until Theodore Reff proved that it must represent a fellow artist, Henri Michel-Lévy, whom Degas knew quite well. Two of his picnic scenes are shown hanging on the walls of the studio. The most disturbing feature of the painting is the limp, studio lay-figure; and the relationship between the impassive, dominating man and the submissive female figure is remarkably close to that between Thérèse and Laurent in the *Interior* (Plate 17).

47. Edgar Degas (1834–1917): *Woman putting on her Gloves*. About 1877. Canvas, 60.9 × 46.9 cm. (24 × 18½ in.) Private Collection

48. Edgar Degas (1834–1917): *Henri Michel-Lévy in his Studio*. Signed; about 1878. Canvas, 40 × 28 cm. (15¾ × 11 in.) Lisbon, Calouste Gulbenkian Museum

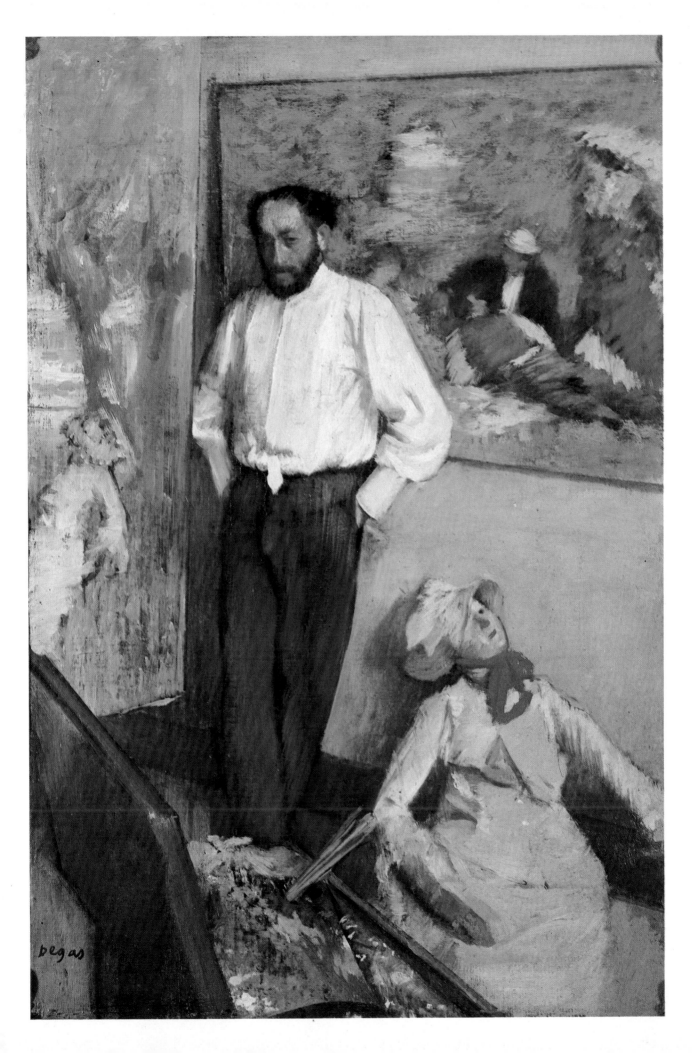

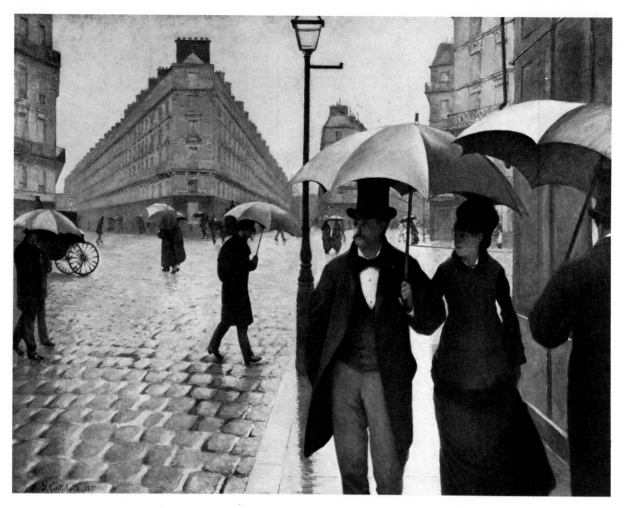

49. Gustave Caillebotte (1848–94): *On a Rainy Day, Place de l'Europe*. Signed and dated 1877. Canvas, 212 × 276 cm. (83½ × 108¾ in.) Chicago Art Institute (Charles H. & Mary F. S. Worcester Collection)

Caillebotte was a minor figure in the history of Impressionism. Like Bazille, he had money and was a generous collector of his friends' works. When he died he left sixty-five paintings to the French nation, and it was a bequest that caused great embarrassment. Although Impressionism was no longer quite the threat it had once been, and Degas, Monet and Renoir were being taken quite seriously, the idea of their paintings actually hanging in the Louvre caused an uproar in official circles. As Gérôme put it, 'for the government to accept such filth, there would have to be a great moral slackening'. Eventually thirty-eight canvases were chosen, but they were not seen in the Louvre until 1928. *On a Rainy Day*, Impressionist in composition but too wooden in handling, was shown at the Impressionist group show of 1877; and it is possible that Renoir got the idea for his own famous picture (right) from Caillebotte's painting. *The Umbrellas* is not only very charming but also important because it vividly documents the artistic crisis Renoir experienced in the early 1880s. He became convinced that he did not know how to draw properly. While the two little girls on the right belong to his soft-edged and very painterly style of the 1870s, the girl with the hat-box on the left shows the harder edged, more linear style that he adopted about 1881, the painting being worked on and altered over several years.

50. Pierre-Auguste Renoir (1841–1919): *The Umbrellas (Les Parapluies)*. Signed; about 1880–5. Canvas, 180 × 115 cm. (71 × 45¼ in.) London, National Gallery

54

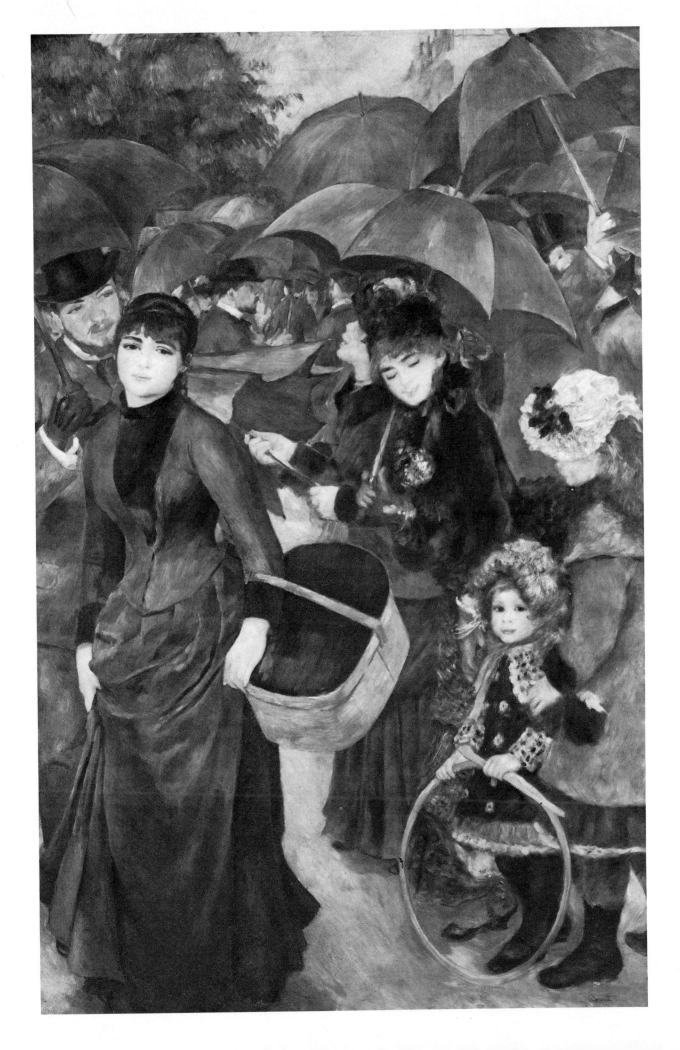

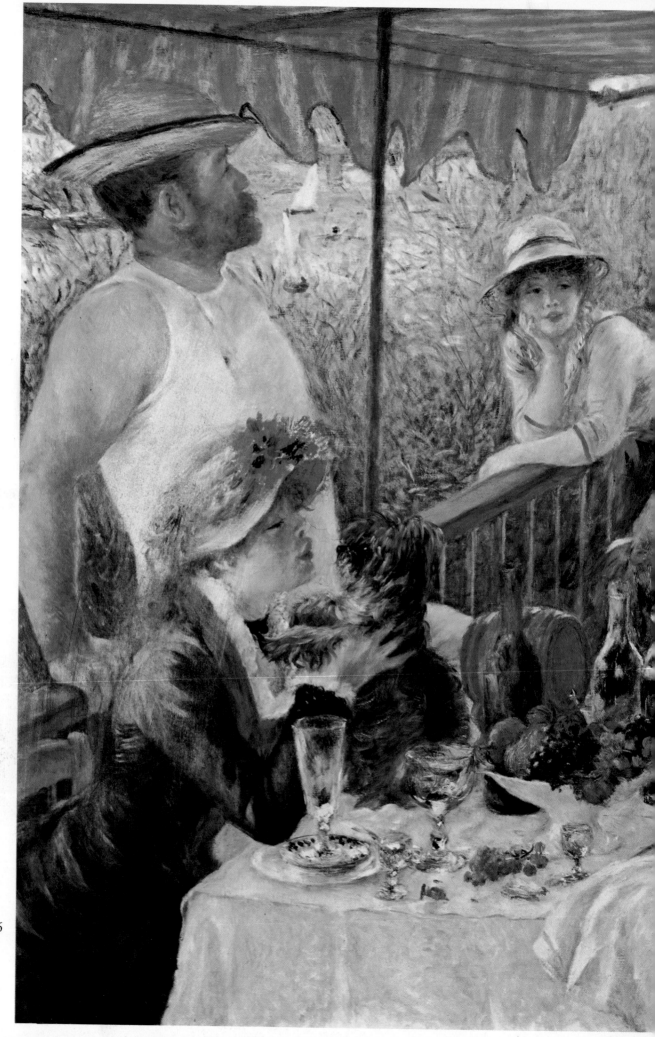

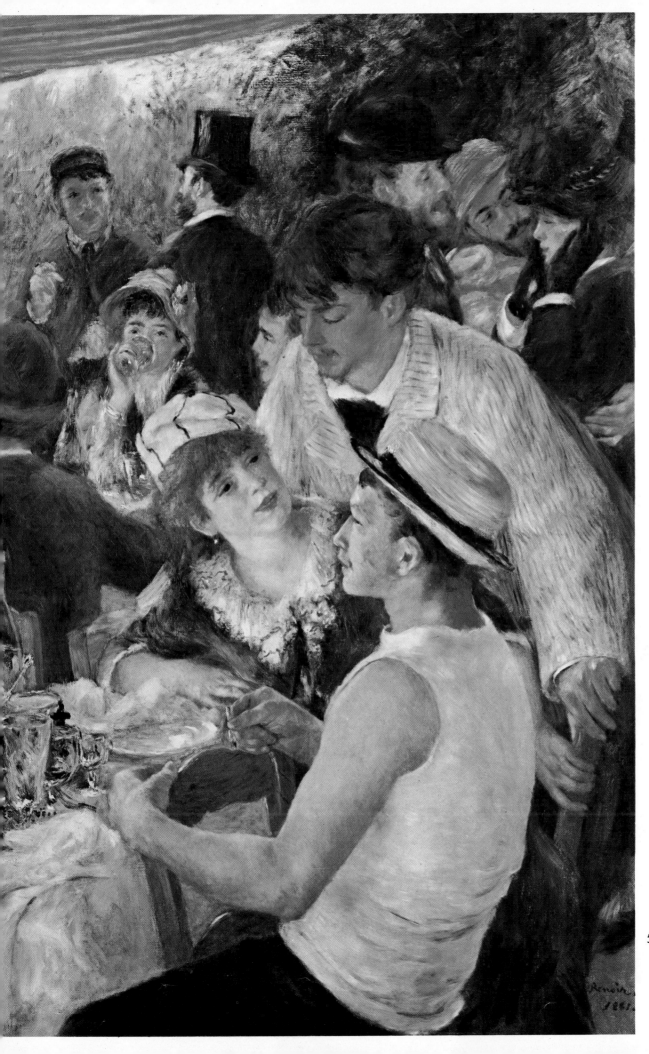

51 (pages 56, 57). Pierre-Auguste Renoir (1841–1919): *The Boatmen's Lunch*. Signed and dated 1881. Canvas, 128 × 174 cm. (50⅜ × 68½ in.) Washington, D.C., The Phillips Collection

52. Edgar Degas (1834–1917): *Place de la Concorde*. Signed; about 1876. Canvas, 79 × 118 cm. (31¾ × 47¼ in.) Formerly Berlin, Gerstenberg Collection (probably destroyed during the Second World War)

Early in 1881 Renoir went to Algiers, where he was enchanted with the light and colourful atmosphere of an alien world. Soon after his return (he was away for only a few weeks), he began work on *The Boatmen's Lunch*, the last and one of the greatest of his masterpieces in the classic Impressionist idiom. The response to colour, heightened by his recent visit to North Africa, is more intense than it had ever been before. Colour is now used not only to describe visual experience but also to intensify the spectator's response to that experience. The white table-cloth is saturated with delicate rainbow-like reflections, like human skin, and the coat of the little dog is conjured out of greens, browns and blues that would never have been seen in ordinary life. *The Boatmen's Lunch* was painted at the restaurant Fournaise on the island of Chatou, which is in the Seine on the outskirts of Paris. As in many of his other pictures of groups, this one also contains portraits of friends and acquaintances. The girl holding the dog, indeed, is Aline Charigot, whom Renoir was to marry in 1890. Opposite, sitting on the chair the wrong way round is the painter, Gustave Caillebotte (see Plate 49). The structure of the composition, with its strong diagonal emphasis, is much the same as that of the earlier, multi-figured composition known as *At the Moulin de la Galette* (1876; Paris, Jeu de Paume).

One of Degas's most important works—tragically now missing and probably destroyed—the *Place de la Concorde* is among the artist's rare street scenes. The approach to the space, with the figures in the foreground cut off by the edges of the composition and with a large empty area behind, shows a strong influence from Japanese prints. The way the man on the right with an umbrella tucked under his arm (a portrait of the Vicomte Lepic) faces in one direction and his two daughters in the other adds to the realism of the scene.

Writing in 1879, Edmond Renoir (the painter's brother) claimed that the artist's work was 'a faithful picture of modern life . . . it is our very existence that he has registered, in pages that are certain to remain among the most living and most harmonious of our age'. Time and familiarity have softened the novelty and realistic effect of Renoir's art; we can now appreciate both its traditional elements and, above all, its high degree of optimism and idealization. Although the composition of the *Place Clichy* is of a type that Degas had already perfected in pictures like the *Place de la Concorde* (which Renoir probably knew), the mood and tone are very different. Degas's carefully calculated air of impartiality has evaporated. The real focus of Renoir's painting is not the anonymous life of a busy street but the ravishing girl in her delightful bonnet.

53. Pierre-Auguste Renoir (1841–1919): *Place Clichy*. Signed; about 1880. Canvas, 64.5 × 54.5 cm. (25½ × 21½ in.) England, Private Collection

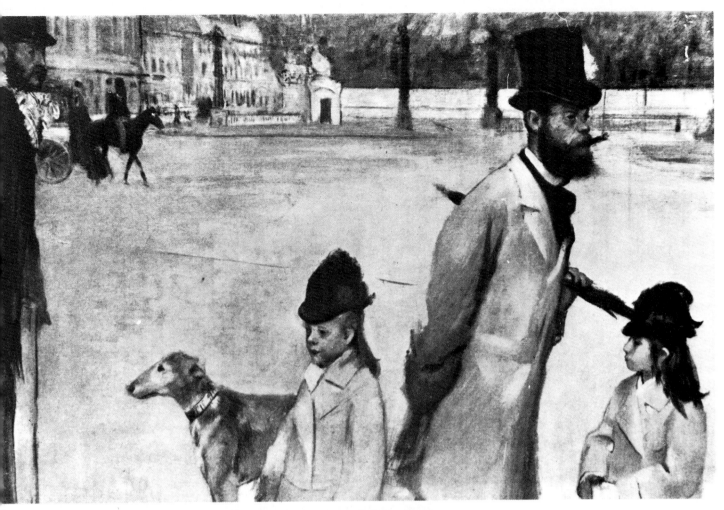

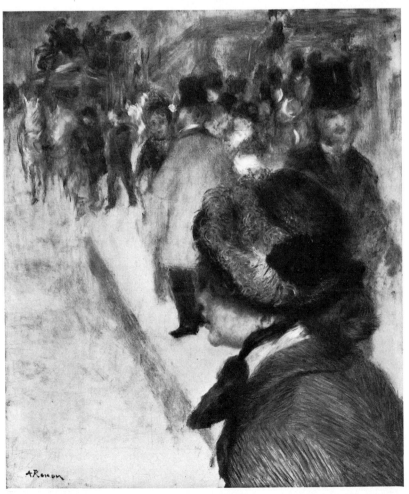

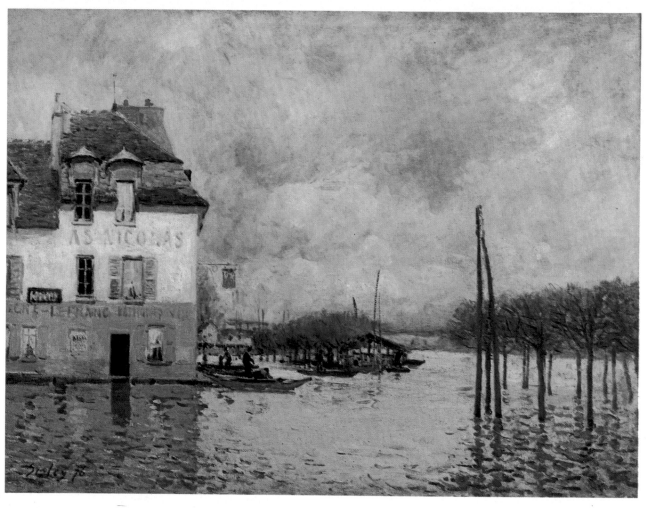

54. Alfred Sisley (1839–99): *Flooding at Port-Marly*. Signed and dated 1876. Canvas, 60 × 81 cm. (25¾ × 32 in.)
Paris, Louvre (Jeu de Paume)

55. Paul Huet (1803–69): *Flooding at Saint-Cloud*. Signed and dated 1855. Canvas, 203.5 × 300 cm. (81 × 120 in.)
Paris, Louvre

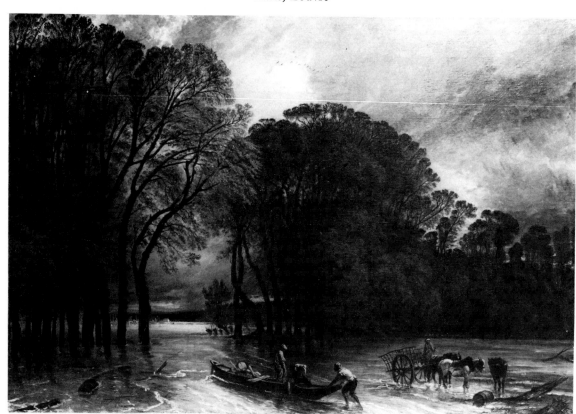

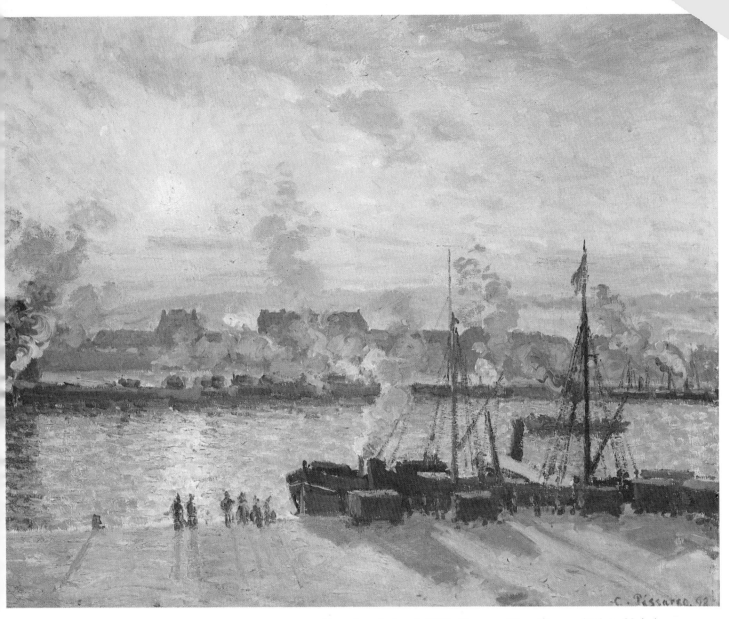

56. Camille Pissarro (1830–1903): *Sunset at Rouen*. Signed and dated 1898. Canvas, 65 × 81 cm. (25½ × 32 in.)
Cardiff, National Museum of Wales (Margaret S. Davies Bequest)

The contrast between the flood scenes of Huet and Sisley brings out, with particular clarity, the essence of the Impressionist approach to landscape. Where Huet is dramatic and rhetorical, working in a tradition that had produced numerous pictures of the Biblical Flood, Sisley deliberately underplays the potential drama. He is almost off-hand; all that seems to matter is the play of light on the water, no matter how hostile the water may be to man's comfort and well-being.

Unlike Sisley, whose art declined after about 1878, Pissarro was able to recapture in the last six or seven years of his life the power of his finest work of the early 1870s. Indeed, some of the best late pictures, like this *Sunset at Rouen*, have a degree of intensity, a celebration of the glory and radiance of light, that is not to be found in his earlier work. Pissarro was painting in Rouen from July to October of 1898; and many of the pictures show that he worked from a high viewpoint (or window), which gave added scope for panoramic effects.

61

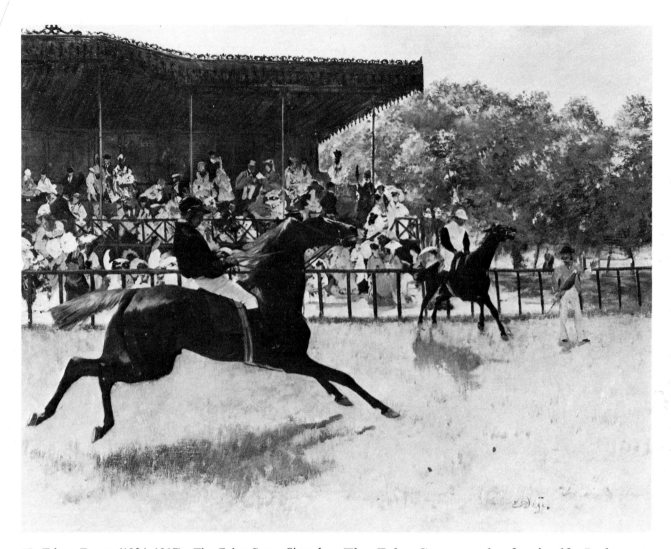

57. Edgar Degas (1834–1917): *The False Start*. Signed; about 1869–71. Canvas, 32 × 41 cm. (12½ × 16 in.) New York, The Hon. John H. & Mrs Whitney

Horses were among Degas's favourite themes in the middle decades of his career—and not just any animals would do. He concentrated almost exclusively on racehorses. Like ballet dancers—another of his main subjects—they had an aura of refinement and high-strung sensitivity that appealed to his love of art and skill in all media. It is characteristic of his naturalistic methods that what he chose to depict was not the excitement of the race itself but the preparations, the animals nervously strutting before the race or even exercising.

The False Start speaks for itself. *Jockeys in the Rain* is ten or twelve years later and more daring in composition. It would be easy to draw a line from the top left to the bottom right corner and demonstrate that virtually half the composition is empty, the horses and riders being confined to the upper triangle. But it is of course precisely this 'emptiness' that contributes so much to the effectiveness of the design, which suggests the casualness of a snapshot. The naturalness of the scene is enhanced by the rain, indicated by the vertical strokes in blue pastel. As his eyesight deteriorated, Degas came to prefer pastel; it was easier to work with than oils and it enabled him to retain colour without sacrificing line.

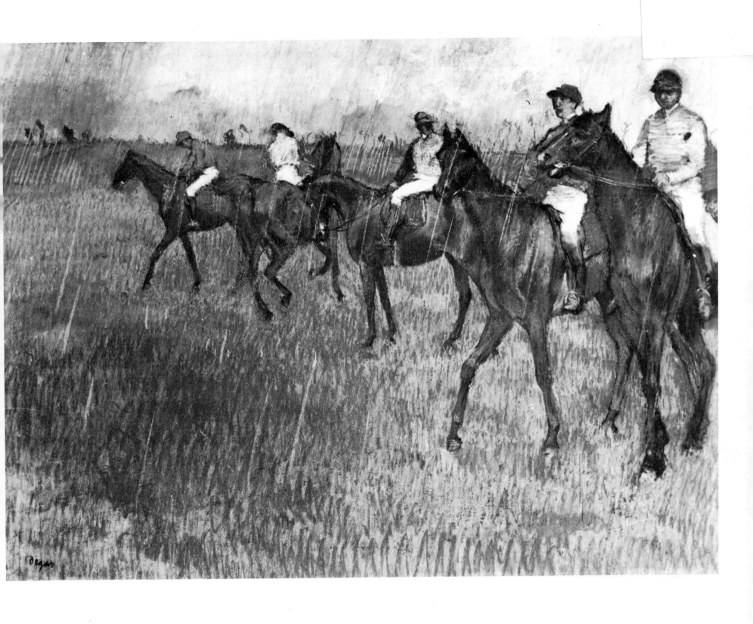

58. Edgar Degas (1834–1917): *Jockeys in the Rain*. Signed; about 1880–1. Pastel on paper, 47 × 65 cm. (18½ × 25 in.)
Glasgow, Museum and Art Gallery (Burrell Loan)

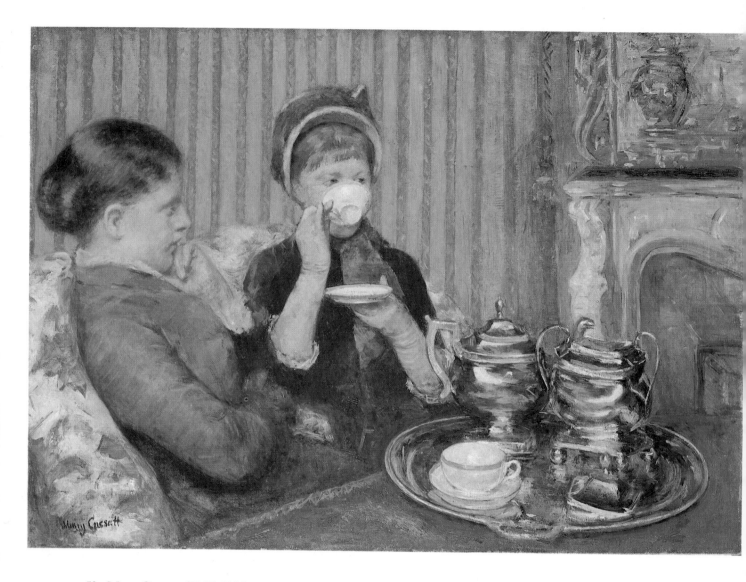

59. Mary Cassatt (1845–1926): *Five O'Clock Tea*. Signed; 1880. Canvas, 64.7 × 92.7 cm. (25½ × 36½ in.) Boston, Museum of Fine Arts (Maria Hopkins Fund)

Mary Cassatt was one of the first American painters to become a fully-fledged Impressionist. She settled in Paris in 1872 and when she exhibited at the official Salon of 1874 her work was noticed by Degas, who took her up, gave advice and encouragement and introduced her to Impressionist circles. She had a good deal of natural ability but lacked, for example, Degas's incisiveness of vision. Her favourite subjects were female and domestic, particularly the relationship of mother and child. *Five O'Clock Tea* was shown at the

fifth Impressionist exhibition in 1880. Sargent's portrait of the wife of the Chilean consul in Paris was exhibited in the following year at the Salon, where it attracted a good deal of favourable attention and won a second-class medal. Sargent was never a strict Impressionist, but he was heavily influenced by their ideas. He knew Monet well and studied his work attentively (see Plate 62). Madame Subercaseaux's pose, half turned and with the weight of the body thrown back, must owe a good deal to Degas, whose portrait of Tissot

(Plate 22) was probably known to Sargent. Although he continued to paint informal studies in an Impressionist vein for his own pleasure (see Plate 67), Sargent was to make his name and international reputation from portraiture, in which he combined the new ideas with formulae derived from the Old Masters, creating imagery that was at once reassuring and piquantly up-to-date.

Although Monet's great modern reputation is based on such classic pictures as *The Picnic* (Plate 13) and *The Seine at Bougival* (Plate 14), he was constantly experimenting with new themes and images. Studying a group of his pictures, like those on view in the Jeu de Paume in Paris, one is struck by the great variety of weather and mood in his work, from the storm scenes painted on the Atlantic coast to the haystacks basking in the sunlight. *The Promenade* overleaf is one of a series in which he tried to pin down the fleeting effects of light and shadow by combining figure and landscape in more or less equal proportions. The suggestion of breeze lightly ruffling the girl's skirt adds to the impression of the weather's capriciousness. Monet's actual handling of paint has also begun to change. Instead of the small dab strokes, common in the early work (Plates 13 and 26), he was by the mid-1870s using longer and wirier strokes.

Sargent's painting overleaf on the right owes much to Monet and is extremely well painted —look at the way the sunlight, falling through leaves, dapples the girl's white dress. But the image is neither as tough nor as original as Monet's. Sargent is careful to show his young lady's face, and he makes sure it is pretty, whereas for Monet the girl is merely a figure in a landscape.

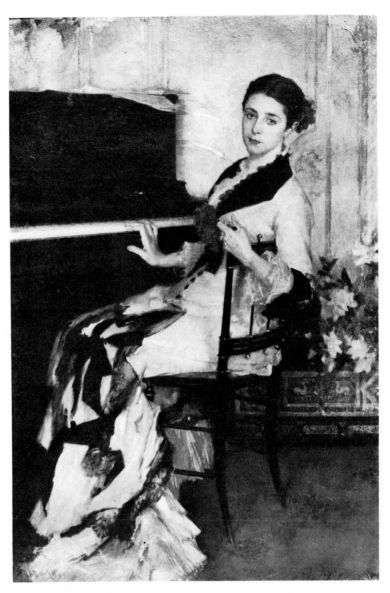

60. John Singer Sargent (1856–1925): *Madame Ramón Subercaseaux*. Signed; 1880. Canvas, 165.2 × 110.5 cm. (65 × 43½ in.) Santiago, Chile, Señora Amalia Barros de Griffin

Overleaf left: 61. Claude Monet (1840–1926): *The Promenade, Woman with a Parasol*. Signed and dated 1875. Canvas, 100 × 81 cm. (39⅜ × 31⅜ in.) Washington, D.C., National Gallery of Art (Mr & Mrs Paul Mellon Collection)

Overleaf right: 62. John Singer Sargent (1856–1925): *A Morning Walk*. Signed; about 1888. Canvas, 67 × 50.2 cm. (26⅜ × 19¾ in.) Private Collection

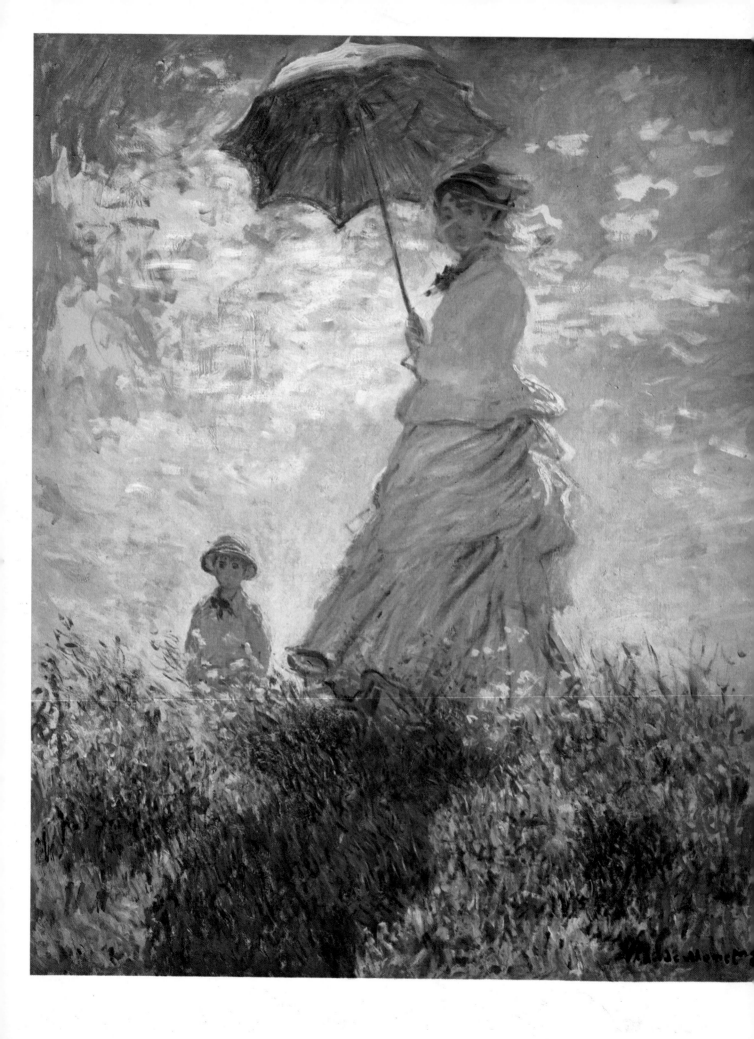

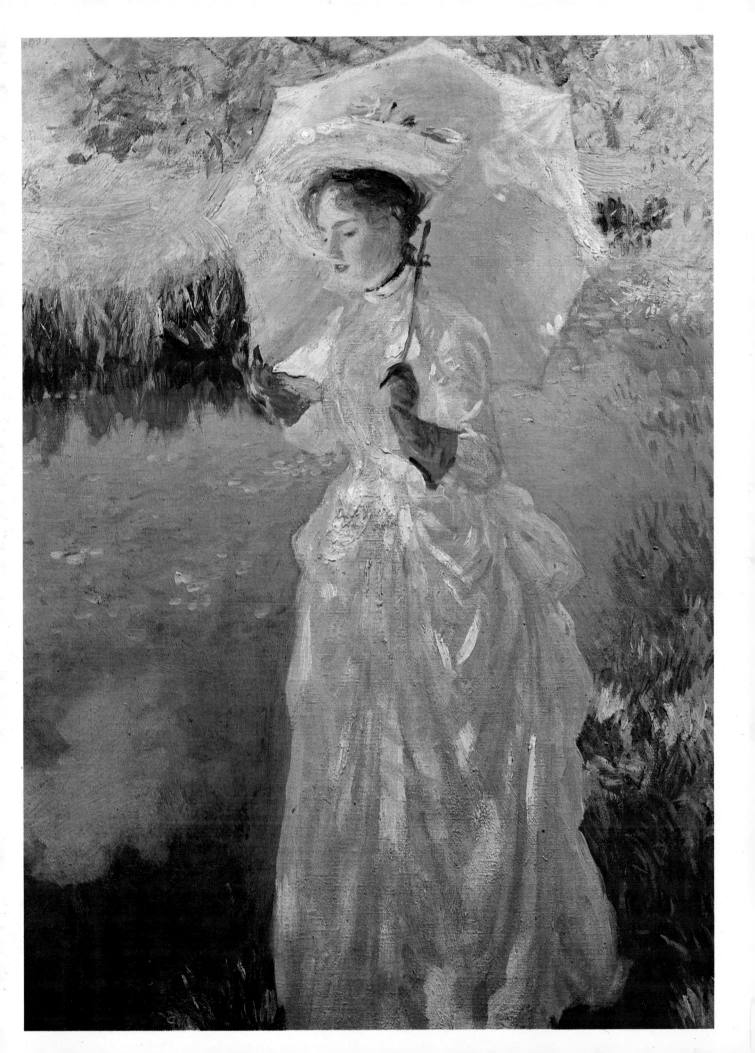

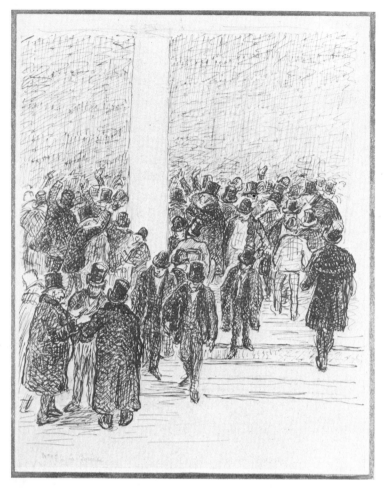

Pissarro's lyrical view of nature is in some respects misleading. Although he always concentrated on landscape and produced relatively few figure subjects, and even fewer portraits, he was very much alive to the social and political life of his time. Plate 63 reproduces one of a series of twenty-eight sketches that he grouped together in an album entitled *Turpitudes Sociales*, with captions inspired by or quoted from Grave's anarchist publication, *La Révolte*. The composition of *The Paris Stock Exchange* shows Degas's influence in its informality and high viewpoint; Degas himself twice painted the Stock Exchange and exhibited the pictures at the second (1876) and fourth (1879) Impressionist group exhibitions.

Although the Impressionists aimed to give an unbiased and truthful account of the world about them, the view of life that we are given through their art is very unbalanced. The world they depict is distinctly optimistic with very few signs of the Industrial Revolution. Degas was interested in the theme of laundry women not for its social implications but as one more opportunity to study professionals going about their appointed tasks. The laundress was on a par with the dancer, the milliner and the jockey.

63. Camille Pissarro (1830–1903): *The Paris Stock Exchange*. 1889–90. Pen and ink over pencil tracings, 22.5 × 18 cm. (8⅞ × 7⅛ in.) Oxford, Ashmolean Museum

64. Edgar Degas (1834–1917): *Woman Ironing*. Signed; 1882. *Essence* (oil thinned with turpentine) on card, 81 × 65 cm. (31⅞ × 25⅝ in.) Washington, D.C., National Gallery of Art (Paul Mellon Collection)

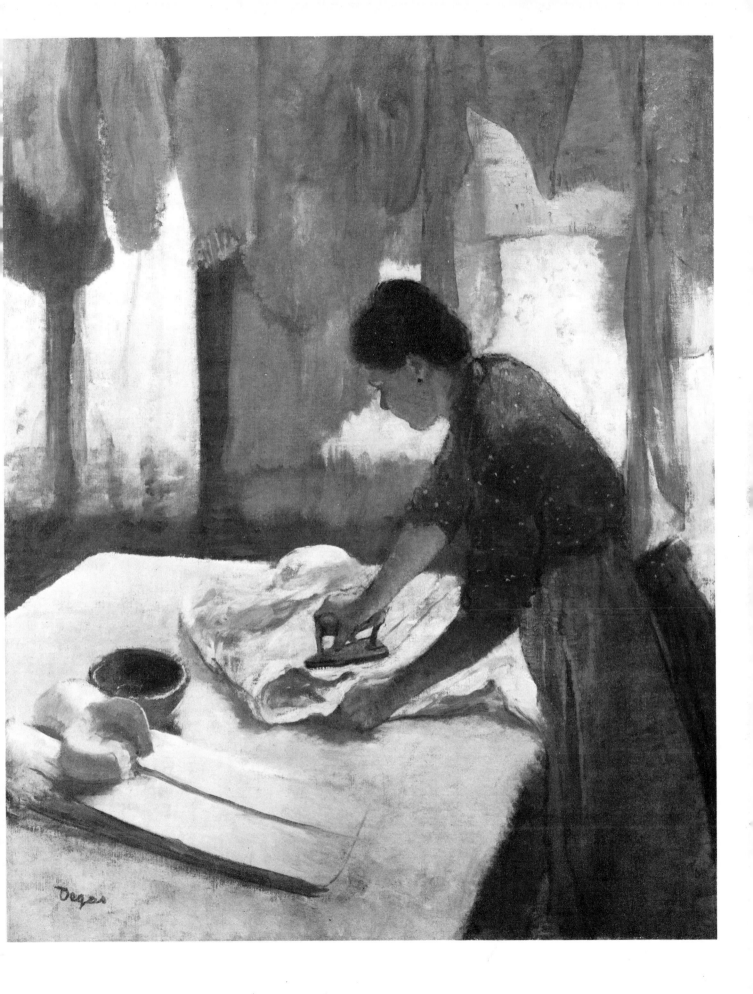

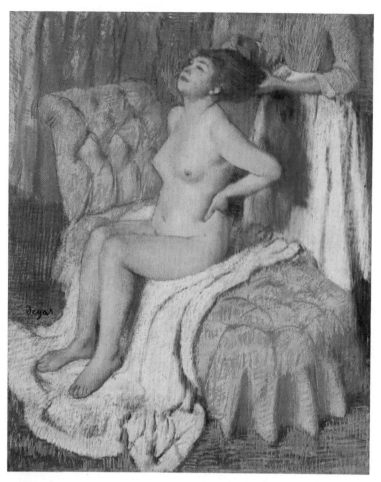

Degas's pastel, among his most beautiful studies of the nude, was probably exhibited at the eighth and last of the Impressionist group exhibitions in 1886. The effect of intimacy without the seductive overtones usually associated with the theme was intentional: Degas himself told the Irish writer, George Moore, that his nudes represented 'the human beast occupied with herself, a cat licking herself'. The rather flattened-out space and the abrupt way the maid's figure is cut by the top of the design are devices that Degas learned primarily from Japanese prints, of which he was an ardent admirer and collector.

Mary Cassatt became a close friend of Degas, who included her in several pictures as well as the famous etching of *Mary Cassatt in the Louvre* (1879-80); and she shared his enthusiasm for the colourful prints from Japan. It was actually an exhibition of Ukiyo-e woodcuts at the Ecole des Beaux-Arts in Paris in the spring of 1890 that inspired a set of ten coloured aquatints, executed as 'an imitation of Japanese methods'. They are technically more complex than the originals, which were printed from simple wood-blocks, a point noted by Camille Pissarro, who described them in a letter to his son as 'admirable, as beautiful as Japanese work, and it's done with printer's ink'. Mary Cassatt's prints were also conceived as complements to specific Japanese originals; and *Woman Bathing* relates to Utamaro's *Woman at her Toilette, reflected in Hand Mirrors*.

65. Edgar Degas (1834–1917): *A Woman having her Hair Combed*. Signed; about 1886. Pastel, 74 × 60.6 cm. (29⅛ × 23⅞ in.) New York, Metropolitan Museum of Art (Bequest of Mrs H. O. Havemeyer, 1929)

66. Mary Cassatt (1845–1926): *Woman Bathing*. 1891. Drypoint, soft-ground etching, and aquatint, fifth state; painted in colour, 36.2 × 24.1 cm. (14 5/16 × 10 9/16 in.) New York, Metropolitan Museum of Art (Gift of Paul J. Sachs, 1916)

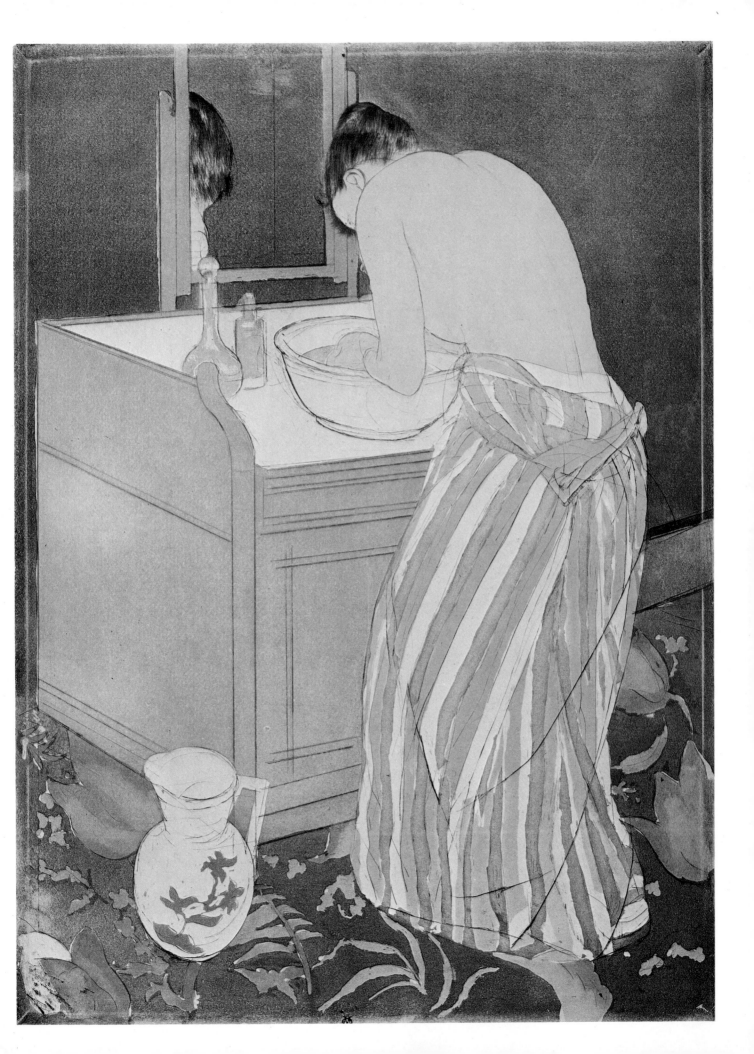

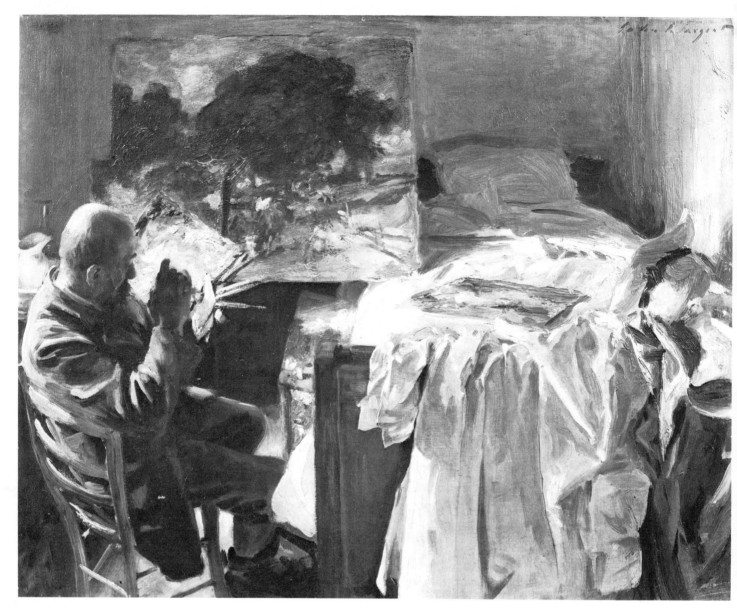

67. John Singer Sargent (1856–1925): *His Studio*. Signed; about 1904. Canvas, 54.6 × 71.8 cm. (21½ × 28¼ in.)
Boston, Museum of Fine Arts (Charles Henry Hayden Fund)

By 1904, Sargent was at the height of his reputation as the leading fashionable portrait painter of the day; but the rôle had become increasingly irksome, and from about 1907 he painted fewer and fewer portraits. He had never given up working direct from nature, in the Impressionist tradition, as this charming oil study demonstrates. The rather high viewpoint, looking down on the bed and the painter, is very much in the Degas manner (compare Plate 33). The sitter was an Italian painter named Ambrogio Raffele (1845-1928)

and he sat for other oil and watercolour studies by Sargent.

The *Girl wiping her Foot* should come as both a corrective and a surprise to anyone who thinks that all Pissarro's figures are rather stodgy peasants. It is in fact one of his most enchanting female studies and was made in preparation for an oil-painting of 1895.

68. Camille Pissarro (1830–1903): *Girl wiping her Foot*. 1895. Pastel and chalk, 38 × 29.1 cm. (15 × 11½ in.)
Oxford, Ashmolean Museum

72

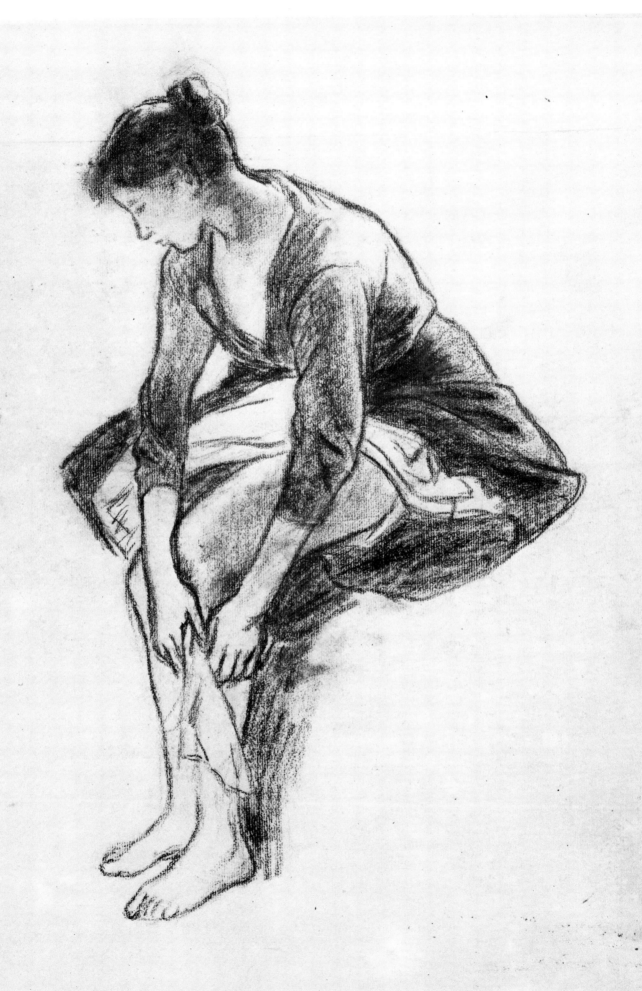

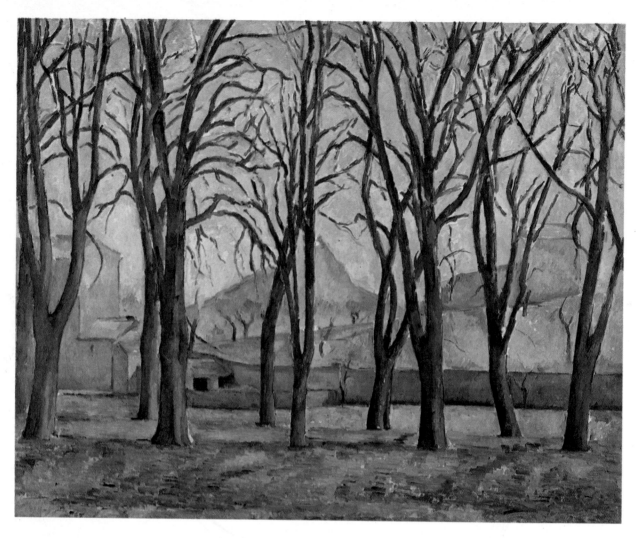

69. Paul Cézanne (1839–1906): *Alley of Chestnut Trees at the Jas de Bouffan*. 1885–7. Canvas, 74.9 × 94 cm. (29½ × 37 in.) Minneapolis, Institute of Arts

Cézanne studied with Pissarro for a short time (1872-4) and was influenced by his art. Pissarro's sense of pictorial structure, much stronger than that of Monet or Renoir, appealed to Cézanne's developing interest in the 'architecture' of a painting, an element in which he felt most Impressionist pictures were weak. The landscape reproduced here, a view in the grounds of the family estate near Aix-en-Provence, shows the way in which he has sacrificed the immediacy of sunlight effects in favour of small strokes that suggest the form rather than the actual appearance of the trees and walls. Impressionist influence is still very clear but this canvas already belongs to the early phase of Post-Impressionism, in

which—speaking very generally—it is true to say the balance shifts from the naturalistic effects of Impressionism towards a much more consciously artificial view of subject-matter.

Childe Hassam was one of the more interesting American painters to work in the Impressionist idiom. He travelled in Europe in the 1880s and stayed in Paris, where he was able to see the latest work. He came closest to the style of Monet; *Washington Arch in Spring* has the feathery lightness of touch characteristic of Monet's pictures of the mid-1880s. His favourite subjects were New York and the Connecticut countryside.

70. Childe Hassam (1859–1935): *Washington Arch in Spring*. Signed and dated 1890. Canvas, 66 × 54.6 cm. (26 × 21½ in.) Washington, D.C., The Phillips Collection

74

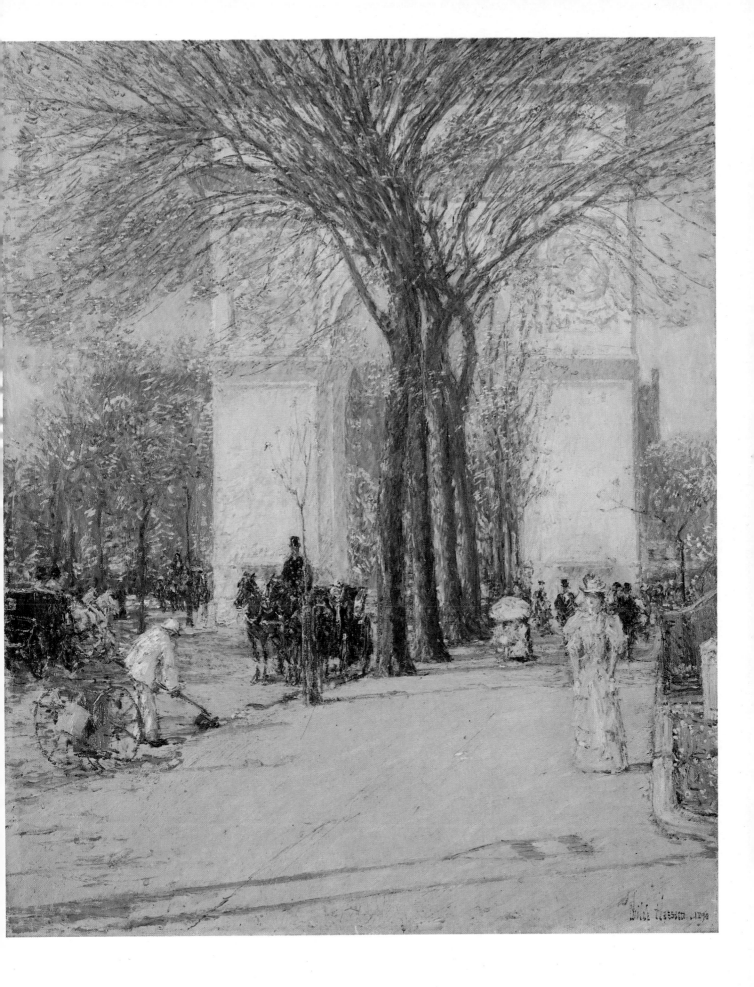

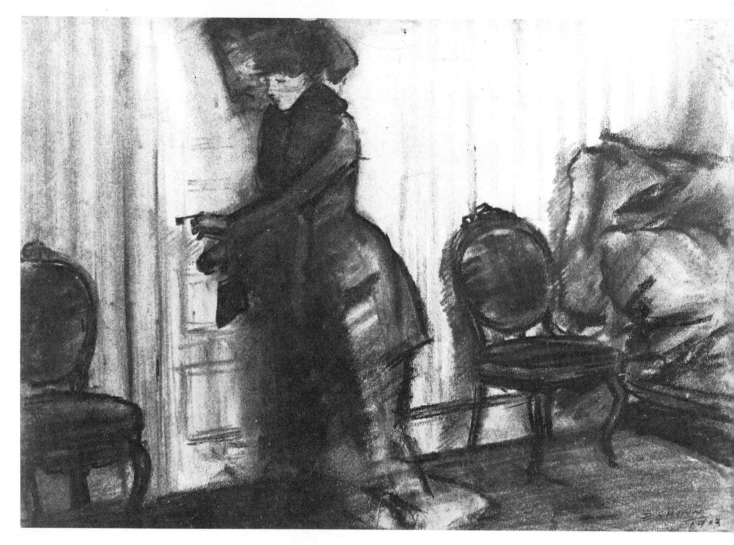

71. Everett Shinn (1876–1953): *Woman opening a Door*.
Signed and dated 1903. Charcoal and gouache on paper,
30.5 × 43.5 cm. (12 × 17⅛ in.) Houston, Texas, Museum
of Fine Arts (purchased with funds donated by Mr & Mrs
W. Brian Trammel, Jr)

Everett Shinn began his career as a mechanical
draughtsman and newspaper illustrator but
joined the New York group known as 'The
Eight', which at the turn of the century was
committed to a form of vivid realism. *Woman
opening a Door* reveals, in its spontaneity, its
deliberately casual composition and use of a
figure caught in mid movement, a general
Impressionist influence. By 1900 Impressionist
ideas no longer seemed very frightening,
except to diehard conservatives—and that
group, unfortunately, included most museum
curators.

Sickert was by far the most talented of the
English Impressionists. He had been in Paris
and was on very good terms with Degas,
whose work was of profound importance for
his own development as a painter. In his
various drawings and paintings of the Old
Bedford, a popular music hall of the day, he
took over Degas's 'slice of life' methods of
composition and unusual viewpoints: the
gallery of the theatre is seen in sharp per-
spective from below. Note, too, how Sickert
has exploited the giant mirror to provide a
second image of the crowded seats.

72. Walter Richard Sickert (1860–1942): *The Gallery of
the Old Bedford*. Signed; about 1894. Charcoal on toned
paper, 54.6 × 38.1 cm. (21½ × 15 in.) England, Private
Collection

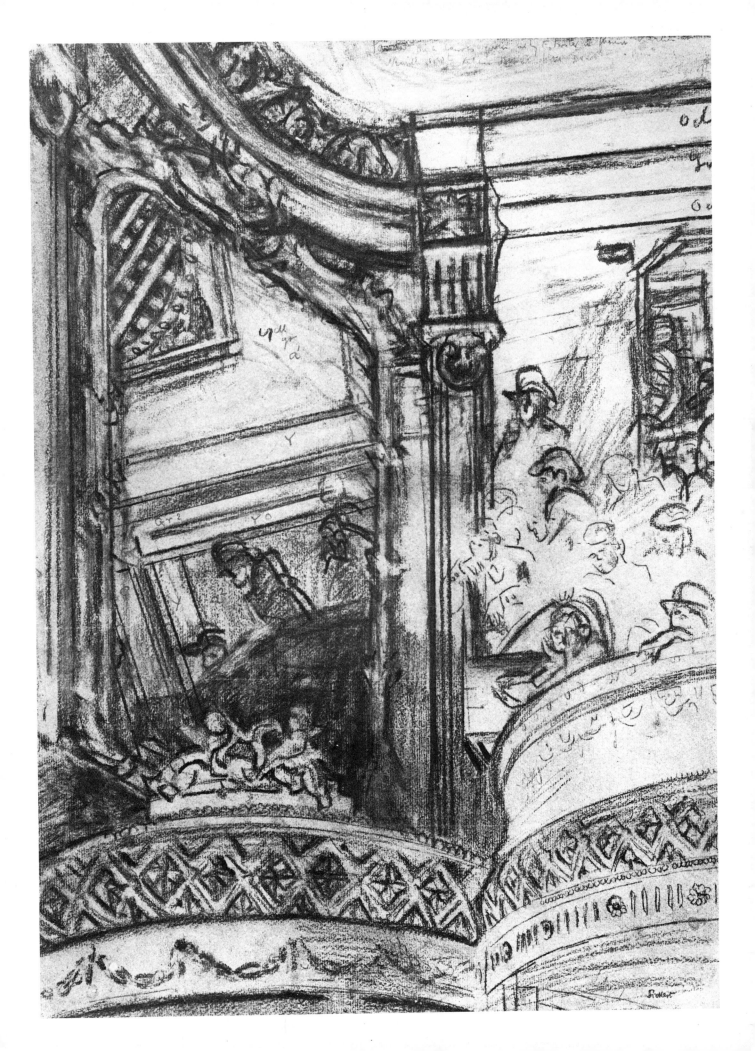

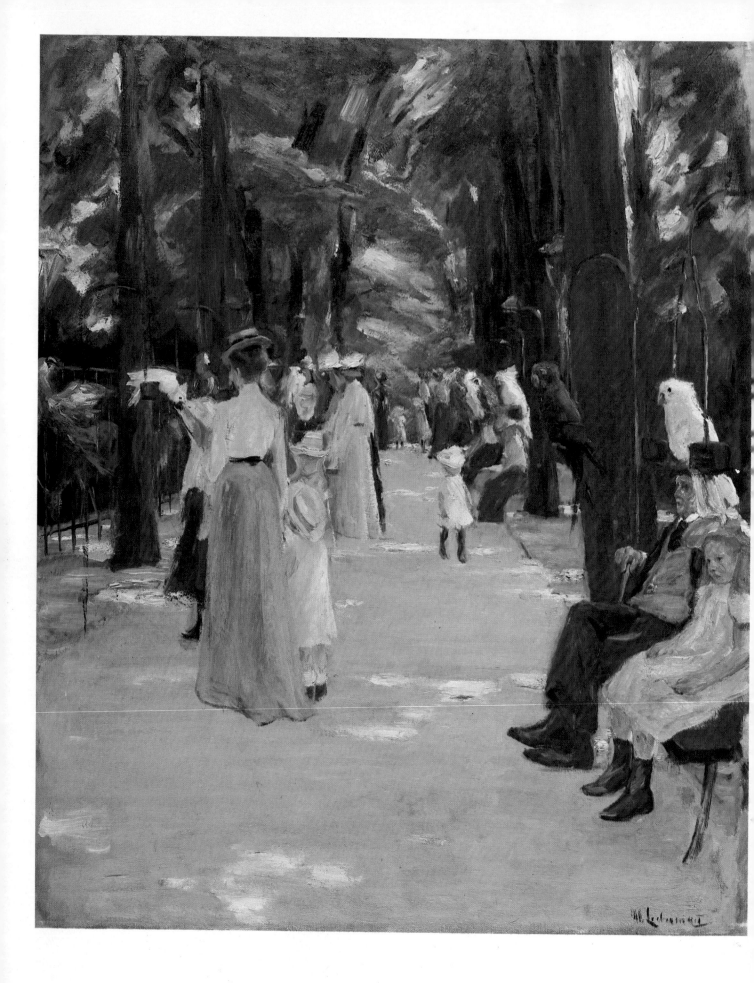

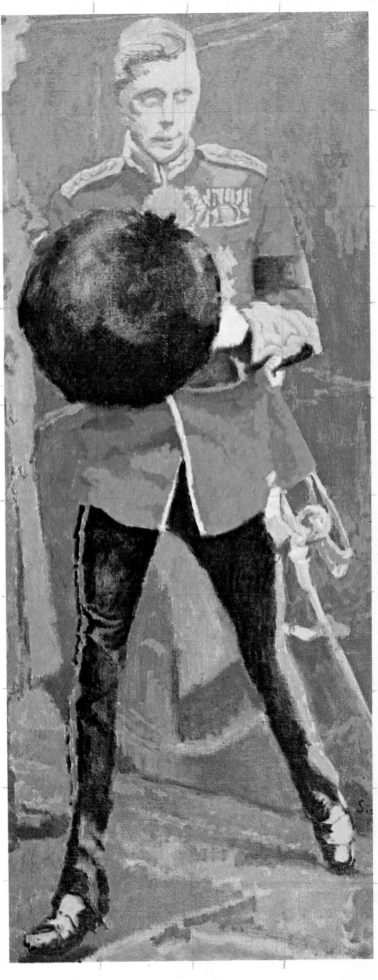

Max Liebermann was the most important exponent of Impressionism in Germany. Although he travelled a good deal, and was in Paris in 1873 for example, he did not develop a fully Impressionist manner until the early 1890s, when he fell under the spell of Manet. Later he was to be influenced by Degas. The painting reproduced here is characteristic of his always fluent and skilful but also faintly coarse style.

Photographs had always been a minor but important influence on the Impressionists. Degas, in particular, was fascinated by their often accidentally achieved effects, blurred details, perhaps, or the sudden cropping of part of a figure (see Plates 7 and 52). Sickert, in old age, took a renewed interest in photography and based several paintings of the royal family on newspaper photographs. This one, of the briefly reigning Edward VIII, was taken from a press photograph by Harold J. Clements and shows the king in the uniform of an officer of the Welsh Guards, arriving at a Church Parade Service of the Welsh Guards on St David's Day (1 March 1936). The painting was completed in a fortnight and, being the first portrait of the new king, was much publicized. Sickert's source was of course a black and white reproduction and he has made no attempt to match the correct, strong shade of red in the uniform.

73. Max Liebermann (1847–1935): *The Parrots' Walk at the Amsterdam Zoo*. Signed; 1902. Canvas, 88.1 × 72.5 cm. (34⅝ × 28½ in.) Bremen, Kunsthalle

74. Walter Richard Sickert (1860–1942): *King Edward VIII* (detail). Signed; 1936. Canvas, 182.9 × 91.5 cm. (72 × 36 in.) Fredericton, New Brunswick (Canada), Beaverbrook Art Gallery

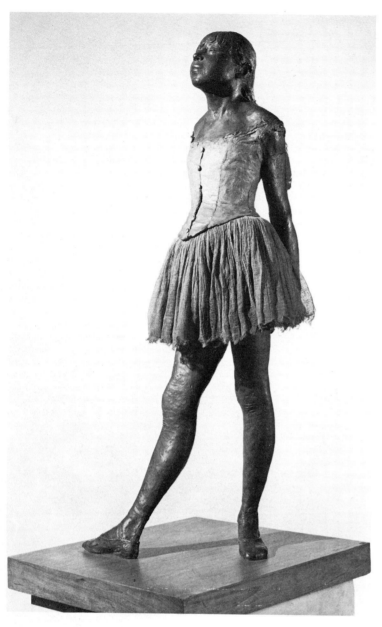

Impressionism has always been basically concerned with painting and graphics. Sculpture is too intractable a medium to lend itself to most of the visual ideas of the movement; although a case might be made for some of Rodin's more daring bronzes, whose multifaceted, light-reflecting surfaces and sense of movement come close to Impressionist thinking. Nor, with two exceptions, did the Impressionists practise as sculptors. One was Renoir, most of whose bronzes are late in date and conservative in character. The other was Degas, who was always extremely secretive about his work. He was apparently interested in sculpture from the early 1860s but most of his surviving statuettes, which were only cast after his death from the wax models found in his studio, date—in their final form—from late in his life when his failing eyesight prevented him from painting but not from modelling in wax by touch. *The Little Dancer aged Fourteen* is not only his most important and largest (surviving) sculpture but the only one that he was willing to exhibit during his lifetime. The original version in wax, but with the same kind of muslin skirt and satin hair-ribbon, was shown at the 1881 Impressionist group exhibition (No. 12). In his desire for lifelike effects, Degas went back to the procedures of the early Renaissance sculptors, who, in the pursuit of realism, often added real objects—swords, lances or even spectacles —after their figures had been carved or cast.

75. Edgar Degas (1834–1917): *The Little Dancer aged Fourteen*. 1880–1. Bronze with muslin skirt and satin hair-ribbon, on wooden base, height, 99 cm. (39 in.) London, Tate Gallery